MISCHIEF

We Are Arrested

By Can Dündar

Adapted by Pippa Hill and Sophie Ivatts

Day of The Living

Co-Creator and Writer Juliet Gilkes Romero
Co-Creator and Music & Lyrics Darren Clark
Co-Creator and Director Amy Draper

OBERON BOOKS
LONDON

WWW.OBERONBOOKS.COM

First published in 2018 by Oberon Books Ltd
521 Caledonian Road, London N7 9RH
Tel: +44 (0) 20 7607 3637 / Fax: +44 (0) 20 7607 3629
e-mail: info@oberonbooks.com / www.oberonbooks.com

A catalogue record for this book is available from the British Library.

PB ISBN: 978-1-78682-557-5
E ISBN: 978-1-78682-558-2

Cover image: RSC Visual Communications/Sergil Sverdielov/123rf
Printed and bound by 4EDGE Limited, Hockley, Essex, UK.
eBook conversion by CPI Group (UK) Ltd, Croydon, CR0 4YY.

Visit www.oberonbooks.com to read more about all our books and to buy them. You will also find features, author interviews and news of any author events, and you can sign up for e-newsletters so that you're always first to hear about our new releases.

Printed on FSC accredited paper

Contents

ABOUT THE ROYAL SHAKESPEARE COMPANY

The Shakespeare Memorial Theatre opened in Stratford-upon-Avon in 1879. Since then the plays of Shakespeare have been performed here, alongside the work of his contemporaries and of living modern playwrights. In 1960, the Royal Shakespeare Company was formed, gaining its Royal Charter in 1961. The founding principles of the Company were threefold: the Company would embrace the freedom and power of Shakespeare's work, train and develop young actors and directors and, crucially, experiment in new ways of making theatre. The RSC quickly became known for exhilarating performances of Shakespeare alongside new masterpieces such as *The Homecoming* and *Old Times* by Harold Pinter. It was a combination that thrilled audiences and this close and exacting relationship between writers from different eras has become the fuel that powers the creativity of the RSC.

In 1974, The Other Place opened in a tin hut on Waterside under the visionary leadership and artistic directorship of Buzz Goodbody. Determined to explore Shakespeare's plays in intimate proximity to her audience and to make small-scale, radical new work, Buzz revitalised the Company's interrogation between the contemporary and classical repertoire. Reopened in 2016 under the artistic directorship of Erica Whyman, The Other Place is once again the home for experimentation and the development of exciting new ideas.

The Other Place was generously supported using public funding by ARTS COUNCIL ENGLAND, and with grants from THE GATSBY CHARITABLE FOUNDATION, BACKSTAGE TRUST and J PAUL GETTY JR CHARITABLE TRUST.

In our 55 years of producing new plays, we have collaborated with some of the most exciting writers of their generation. These have included: Edward Albee, Howard Barker, Alice Birch, Richard Bean, Edward Bond, Howard Brenton, Marina Carr, Caryl Churchill, Martin Crimp, David Edgar, Helen Edmundson, James Fenton, Georgia Fitch, Fraser Grace, David Greig, Tanika Gupta, Matt Hartley, Ella Hickson, Dennis Kelly, Anders Lustgarten, Tarell Alvin McCraney, Martin McDonagh, Tom Morton-Smith, Rona Munro, Richard Nelson, Anthony Neilson, Harold Pinter, Phil Porter, Mike Poulton, Mark Ravenhill, Somalia Seaton, Adriano Shaplin, Tom Stoppard, debbie tucker green, Frances Ya-Chu Cowhig, Timberlake Wertenbaker, Peter Whelan and Roy Williams.

The Company today is led by Gregory Doran, whose appointment as Artistic Director represents a long-term commitment to the disciplines and craftsmanship required to put on the plays of Shakespeare. The RSC under his leadership is committed to illuminating the relevance of Shakespeare's plays and the works of his contemporaries for the next generation of audiences and believes that our continued investment in new plays and living writers is an essential part of that mission.

The RSC is grateful for the significant support of its principal funder, Arts Council England, without which our work would not be possible. Around 75 per cent of the RSC's income is self-generated from Box Office sales, sponsorship, donations, enterprise and partnerships with other organisations.

Supported using public funding by
ARTS COUNCIL ENGLAND

NEW WORK AT THE RSC

We are a contemporary theatre company built on classical rigour. Through an extensive programme of research and development, we resource writers, directors and actors to explore and develop new ideas for our stages, and as part of this we commission playwrights to engage with the muscularity and ambition of the classics and to set Shakespeare's world in the context of our own.

We invite writers to spend time with us in our rehearsal rooms, with our actors and creative teams. Alongside developing new plays for all our stages, we invite playwrights to contribute dramaturgically to both our productions of Shakespeare and his contemporaries, as well as our work for, and with, young people. We believe that engaging with living writers and contemporary theatre-makers helps to establish a creative culture within the Company which both inspires new work and creates an ever more urgent sense of enquiry into the classics.

Shakespeare was a great innovator and breaker of rules, as well as a bold commentator on the times in which he lived. It is his spirit which informs new work at the RSC. Erica Whyman, Deputy Artistic Director, heads up this strand of the Company's work alongside Pippa Hill as Literary Manager.

The work of the RSC Literary Department is generously supported by THE DRUE HEINZ TRUST.

The spring 2018 Mischief Festival was first presented by the
Royal Shakespeare Company in The Other Place, Stratford-upon-Avon,
on 31 May 2018. The cast was as follows:

#WeAreArrested by Can Dündar, adapted by Pippa Hill and Sophie Ivatts

From the English translation by Feyza Howell

SON	**JAMIE CAMERON**
GUNMAN	**ALVARO FLORES**
CAN	**PETER HAMILTON DYER**
WIFE	**INDRA OVÉ**

Day of the Living created by Darren Clark, Amy Draper and
Juliet Gilkes Romero

ENSEMBLE	**JAMIE CAMERON**
	ALVARO FLORES
	JIMENA LARRAGUIVEL
	EILON MORRIS
	ANNE-MARIE PIAZZA
	TANIA MATHURIN

The RSC Acting Companies are generously supported by THE GATSBY
CHARITABLE FOUNDATION and THE KOVNER FOUNDATION.

#WeAreArrested

By Can Dündar

Adapted by Pippa Hill and Sophie Ivatts

From the English translation by Feyza Howell

Director	**Sophie Ivatts**
Designer	**Charlie Cridlan**
Lighting Designer	**Claire Gerrens**
Sound Designer	**Oliver Soames**
Movement Director	**Ingrid Mackinnon**
Magic Consultant	**John Bulleid**
Company Voice and Text Work	**Kate Godfrey**
Assistant Director	**Caroline Wilkes**
Casting Director	**Matthew Dewsbury**
Dramaturg	**Pippa Hill**
Production Manager	**Julian Cree**
Costume Supervisor	**Zarah Meherali**
Props Supervisor	**Jess Buckley**
Company Stage Manager	**Julia Wade**
Assistant Stage Managers	**Ruth Blakey**
	PK Thummukgool
Producer	**Claire Birch**

Arrangement of 'Hello' by Oguz Kaplangi

'Hello' is written by Adkins/Kurstin and published by EMI/UMP

Day of the Living

Created by Darren Clark, Amy Draper and Juliet Gilkes Romero

Director	**Amy Draper**
Designer	**Charlie Cridlan**
Lighting Designer	**Matt Peel**
Music & Lyrics	**Darren Clark**
Sound Designer	**Jon Lawrence**
Movement Director	**Andrea Peláez**
Mask Director	**Rachael Savage**
Company Voice and Text Work	**Kate Godfrey**
Assistant Director	**Nyasha Gudo**
Casting Director	**Matthew Dewsbury**
Dramaturg	**Nic Wass**
Production Manager	**Julian Cree**
Costume Supervisor	**Zarah Meherali**
Props Supervisor	**Jess Buckley**
Company Stage Manager	**Julia Wade**
Assistant Stage Managers	**Ruth Blakey**
	PK Thummukgool
Producer	**Claire Birch**

Strangeface masks made by Russell Dean

This text may differ slightly from the play as performed.

LOVE THE RSC?

Become a Member or Patron and support our work

The RSC is a registered charity. Our aim is to stage theatre at its best, made in Stratford-upon-Avon and shared around the world with the widest possible audience and we need your support.

Become an RSC Member from £50 per year and access up to three weeks of Priority Booking, advance information, exclusive discounts and special offers, including free on-the-day seat upgrades.

Or support as a Patron from £150 per year for up to one additional week of Priority Booking, plus enjoy opportunities to discover more through special behind-the-scenes events.

For more information visit **www.rsc.org.uk/support** or call the RSC Membership Office on 01789 403440.

CAST

JAMIE CAMERON
SON/ENSEMBLE
RSC: *A Midsummer Night's Dream: A Play for the Nation.*
THIS SEASON: *#WeAreArrested, Day of the Living.*
TRAINED: Central School of Speech and Drama, Royal Academy of Music.
THEATRE INCLUDES: *A Christmas Carol* (Old Vic); *Carmen Disruption* (Almeida); *Once The Musical* (original West End cast/ Dublin/Seoul).
FILM: *Anna Karenina*.

ALVARO FLORES
GUNMAN/ENSEMBLE
RSC DEBUT SEASON: *#WeAreArrested, Day of the Living.*
TRAINED: Italia Conti Academy, Royal Academy of Music.
THEATRE INCLUDES: *Don Quixote in Algiers* (White Bear); *Qaddafi's Cook* (NY/Hollywood Fringe); *Madagascar Live* (Latin American Tour); *La Expulsión* (Mexico tour); *Cuerdas* (El Galeón, Mexico); *Riñones* (Foro Sor Juana, Mexico); *Fair Trado* (Ploooonoo Theatre); *Wig Out!* (Royal Court); *Nine* (Ye Olde Rose and Crown); *ELEKTRA* (Camden People's); *World at One* (King's Head); *Trumpets & Raspberries* (Avondale Theatre); *Mr Puntila* (Sheridan Studio).
TELEVISION AND FILM INCLUDES: *Las Reglas de la Ruina, Fuente Ovejuna, Amor de Barrio, La Virgen de Estambul, Rage, The Fall, Hérue, Otra Vida, The Car, Rictus*.
RADIO INCLUDES: BBC, *The Beauty and the Bear, Disney* (Rossiter & Co).

PETER HAMILTON DYER
CAN
RSC: *A Midsummer Night's Dream: A Play for the Nation, Epicoene.*
THIS SEASON: *#WeAreArrested.*
TRAINED: Central School of Speech and Drama.
THEATRE INCLUDES: *Twelfth Night, Richard III* (West End/Broadway/Shakespeare's Globe); *King Lear* (Tokyo/Shakespeare's Globe); *The Comedy of Errors, The Tempest, Henry VIII, All's Well That Ends Well, Antony and Cleopatra, The Changeling, The Broken Heart, Anne Boleyn, Gabriel, The Frontline, Holding Fire!, The Golden Ass* (Shakespeare's Globe); *One Flew Over the Cuckoo's Nest* (Nimax UK tour); *The Bacchae* (Shared Experience); *Richard II, The Moonstone* (Manchester Royal Exchange); *Mrs Orwell* (Southwark Playhouse); *The Caretaker, David Copperfield* (Dundee).
TELEVISION INCLUDES: *Downton Abbey, Wolf Hall, Silk, Silent Witness, EastEnders, Holby City, Doctor Who, Waking the Dead, The Bill, Doctors.*
RADIO INCLUDES: BBC Radio Rep, *Scribblers, Bretton Woods, Book of the Week, Ulysses, The Colour of Milk, The Cruel Sea, Mrs Dalloway, The Tempest, Songs and Lamentations.*

JIMENA LARRAGUIVEL
ENSEMBLE
RSC DEBUT SEASON: *Day of the Living.*
TRAINED: University of Saskatchowan.
THEATRE INCLUDES: *The House of Bernarda Alba* (Cervantes Theatre); *A Midsummer Night's Dream* (Southwark Playhouse); *Música de Balas* (White Bear Theatre); *Healthy Heart* (Leicester Square Theatre); *Ten Ten Theatre* (national tour); *Sonnet Walks* (Shakespeare's Globe).
TELEVISION: *Apple Tree Yard.*
FILM INCLUDES: *Babies, Conscript, Nine Creek Mile.*

TANIA MATHURIN
ENSEMBLE
RSC DEBUT SEASON: *Day of the Living.*
TRAINED: Arts Educational Schools.
THEATRE INCLUDES: *The Comedy About a Bank Robbery* (Criterion); *The Book of Mormon* (Prince of Wales); *Cinderella* (De Montford Hall/Greenwich); *Porgy & Bess* (Regent's Park Open Air Theatre); *A Christmas Carol, Little Shop of Horrors* (Birmingham Rep); *Wicked* (Victoria Apollo); *Cool Hand Luke* (Aldwych Theatre); *Stepping Out* (Oldham Coliseum); *Hairspray* (Shaftesbury Theatre); *Mary Poppins* (UK tour); *Jack and the Beanstalk* (Watford Palace); *Carmen Jones* (Royal Festival Hall); *Fame* (Arena Theatre); *Jerry Springer The Opera* (National Theatre); *The Lion King* (Germany); *Half a Sixpence* (West Yorkshire Playhouse); *Les Misérables* (UK tour); *Doctor Doolittle* (Apollo, Hammersmith); *Martin Guerre* (Prince Edward); *Me & My Girl* (UK tour).
TELEVISION AND FILM INCLUDES: Nivea advert, *Paranoia.*

EILON MORRIS
ENSEMBLE
RSC DEBUT SEASON: *Day of the Living.*
TRAINED: University of Huddersfield.
THEATRE INCLUDES: *Gaudete* (OBRA Theatre Co/Lowry); *These Trees are Made of Blood* (Arcola/Southwark Playhouse); *A Day in a Year-and-a-Half* (BlackBox, Thessaloniki); *AKA* (Roundhouse); *Electric Field* (IOU Theatre); *Rhein* (Royal Festival Hall); *Collision* (Duende).
FILM INCLUDES: Music for *The Thadows Loom and the Sun is Black*, BFI's *Le Voyage danc la Luno.*
RADIO: *Lord of the Flies.*

INDRA OVÉ
WIFE
RSC DEBUT SEASON: *#WeAreArrested.*
TRAINED: Central School of Speech and
Drama.
THEATRE INCLUDES: *The Ugly One* (Park
Theatre); *The Interrogation of Sandra Bland*
(Bush); *Torn* (Royal Court); *The Curious
Incident of the Dog in the Night Time*
(Gielgud); *Yes Prime Minister* (UK tour); *Ten
Women* (Ovalhouse); *Twelve Angry Women*
(Gutted Theatre Co/Lion & Unicorn); *Etta
Jenks* (Finborough); *Under One Roof* (Kings
Theatre/V&A/Soho Theatre); *Peer Gynt*
(Arcola); *The Seagull* (National Theatre
Studio); *Blinded by the Sun, A Midsummer
Night's Dream* (National Theatre); *900
Oneonta* (Pangloss Productions); *Timon of
Athens* (Young Vic).
TELEVISION INCLUDES: *Unforgotten 3,
Dark Heart, Flack, Good Omens, Marcella,
Requiem, A.D: The Bible Continues, Glue, The
Dumping Ground, Topsy and Tim, Casualty,
Doctors, The Inbetweeners, Midsomer
Murders, Holby City, Best Man, The New
Worst Witch, Attachments, Bugs, Space
Island One, She's Out, Chandler and Co,
Soldier Soldier, The Chief, Desmonds, The
Orchid House.*
FILM INCLUDES: *Finding Your Feet, Second
Spring, Jurassic, Dubois, Still, Wonder, Mr
Invisible, Hellhounds, My One and Only,
Blinding Lights, Cold Dead Hands, Other,
Club Le Monde, It's All About Love, Resident
Evil, Fallen Dreams, The Dreamer, Cleopatra,
Cyberstalking, Wavelengths, More Is Less,
The Fifth Element, Othello, Interview with a
Vampire.*
RADIO INCLUDES: *Community Flock,
Madame Butterfly, The Wide Sargasso Sea,
The Audition.*

ANNE-MARIE PIAZZA
ENSEMBLE
RSC: *Henry IV Parts I and II* (speeches
and songs recording).
THIS SEASON: *Day of the Living.*
TRAINED: Bristol Old Vic Theatre School.
THEATRE INCLUDES: *These Trees are Made
of Blood* (Arcola/Southwark Playhouse);
Sonnet Walks (Shakespeare's Globe); *Wicker
Husband* (The Other Palace); *A Scarborough
Christmas Carol, Pinocchio* (Stephen Joseph
Theatre); *A Well-Remembered Voice*
(Leicester Square Theatre); *Much Ado About
Nothing, Richard III* (Iris Theatre); *Macbeth*
(Southwark Playhouse); *A Christmas Carol*
(Rose Theatre); *The Snow Spider*
(Ovalhouse); *Treasure Island, Alice in
Wonderland* (Nuffield Theatre); *Beauty and
the Beast, Oh! What a Lovely War* (Haymarket
Basingstoke); *What Every Woman Knows*
(Finborough).
FILM INCLUDES: *Strings and Mortar, The
Promoter.*
RADIO INCLUDES: *The Archers, Man in
Black, Faust, I Believe I Have Genius.*

CREATIVE TEAM

JOHN BULLEID
MAGIC CONSULTANT
RSC DEBUT SEASON: #WeAreArrested.
John is a Magic Consultant, actor and magician. He holds the title of Associate of the Inner Magic Circle with Silver Star, one of only 268 magicians worldwide with the title.
THEATRE INCLUDES: *Sherlock Holmes: The Final Curtain* (Theatre Royal Bath); *The Invisible Man*, *Partners in Crime* (Queen's, Hornchurch); *Beauty and the Beast* (Watford Palace); *The Star* (Liverpool Everyman); *The Inn at Lydda* (Shakespeare's Globe); *Dirty Dancing* (Secret Cinema); *Dracula* (Paul Ewing Entertainment, Thailand); *The Gypsy Thread* (National Theatre Studio); *The Ladykillers*, *The Secret Adversary* (Watermill Theatre); *Thark* (Park Theatre); *Alice in Wonderland* (Brewhouse Theatre, Taunton); *Murder Most Fowl* (Quay Arts Centre); *A Midsummer Night's Dream* (Theatre in the Forest).
TELEVISION AND FILM INCLUDE: *Coco Report* (Channel 4 News); *You And Universe*, *Loo* (independent short films).

DARREN CLARK
CO-CREATOR AND MUSIC & LYRICS
RSC DEBUT SEASON: *Day of the Living*.
THEATRE INCLUDES: Music and lyrics: *These Trees Are Made of Blood* (Southwark Playhouse/Arcola); *The Scarecrow's Wedding* (Edinburgh Festival/UK tour/West End); *The Little Gardener* (UK tour); *Our Friends the Enemy* (UK tour/Off Broadway). Lyrics only: *Fantastic Mr Fox* (UK tour). Darren is a founding member of children's theatre company Paper Balloon, writing music and lyrics for all their shows including national tours of *The Grumpiest Boy in the World*, *Once Upon a Snowflake* and *The Boy and the Mermaid*.
Darren has received several awards including the Music Theatre International Stiles & Drewe Mentorship Award in 2016, the Dunedin Operatic Executive Trust Award and The Iris Theatre Panel and Audience Awards. His songs have been finalists in the Stiles & Drewe Best New Song Award for three years running, winning Runner-up in 2015. He has been a finalist for the Cameron Mackintosh Composer in Residence, the KSF Artists of Choice and the Old Vic 12. Darren is a member of the BML Advanced Composer & Lyricist Workshop and the Mercury Musical Developments Advanced Writers Workshop.

CHARLIE CRIDLAN
DESIGNER
RSC DEBUT SEASON: *#WeAreArrested, Day of the Living*.
THEATRE INCLUDES: Recent work: *Caravan* (Vaults Festival Alias London. People's Choice Award); *Da Native*, *Orator* (Far From the Norm); *Umbra* (Dance Adventures); *Zones*, *Zero For the Young Dudes* (Shell Connections at Soho Theatre); *Mr Stink* (national tour/West End); *Shore* (Riverside Hammersmith); *Brixton Stories* (Lyric Hammersmith/tour); *Lights Out Land Girls*, *Eddie & the Gold Tops* (Bad Apple); *Parkway Dreams*, *Getting Here*, *Cuckoo Teapot* (Eastern Angles).
OPERA INCLUDES: *Wagner Dream* (Barbican); *The Magic Flute* (Peacock Theatre); *Carmen*, *The Pearl Fishers*, *La bohème*, *Jago*, *Eleanor Vale* (Wedmore Opera).
SITE-SPECIFIC: *Uncle Vanya* (Wilton's Music Hall); *Top Dog Live!* (Roundhouse); *The Oresteia Trilogy*, *Don Juan*, *Toad of Toad Hall*, *Around the World in 80 Days*, *The Mother* (The Scoop at More London); *Streets* (Theatre Royal, Stratford East/Roof East/Stratford Circus). *Once upon a Time at the Adelphi* and *Liar's Market* both nominated for Off West End Best Design Awards. Her design for *La bohème* was exhibited at the V&A as part of Transformation & Revelation UK Design for Performance 2007-2011.
OTHER INCLUDES: Designs for Diageo, ?What If! Ltd, The Charles Dickens Museum. She is Designer for Wavelength Connect Ltd.

AMY DRAPER
CO-CREATOR AND DIRECTOR
RSC: As Director: *Bob* **(R&D). As Assistant Director:** *The Famous Victories of Henry V.* **Amy also works as a freelance practitioner for the RSC Education Department.**
THIS SEASON: *Day of the Living*.
THEATRE INCLUDES: As Director: *Princess Charming* (Ovalhouse); *These Trees are Made of Blood* (revival. Arcola); *Mother Courage* (Fourth Monkey); *Hansel and Gretel*, *Much Ado about Nothing* (Iris Theatre. Five Off-West End Award nominations, including Best Director); *The Tempest*, *Macbeth*, *These Trees are Made of Blood*, *Usagi Yojimbo*, *Sunday Morning at the Centre of the World* (Southwark Playhouse); *Life on the Refrigerator Door* (Yard Theatre); *The Door* (Park Theatre); *Angel Cake* (Camden People's Theatre). As Assistant Director: *Comus* (Shakespeare's Globe) and shows at the Arcola, Gate and Finborough. In 2013 she was the Community Director for the CASA Latin American Theatre Festival.

CAN DÜNDAR
WRITER
RSC DEBUT SEASON: #WeAreArrested.
Can Dündar has been working as a journalist for the last 40 years, for several newspapers and magazines. He has produced many TV documentaries focusing particularly on modern Turkish history and cultural anthropology. He worked as an anchorman for several news channels. He stepped down from his post as the editor-in-chief of the daily *Cumhuriyet* in August 2016, after he was sentenced to five years and 10 months of imprisonment due to his story on the Turkish Intelligence Service's involvement in the Syrian war. He is a columnist for German daily *Die Zeit* and commentator for German WDR's *Cosmo*. He founded the news website called #Özgürüz in exile.
Dündar was nominated as a candidate for the Nobel Peace Prize in 2017. He is the writer of more than 40 books, one of which, *We Are Arrested*, was published in England in 2016. His works were awarded prizes by 10 international organisations last year.

CLAIRE GERRENS
LIGHTING DESIGNER
RSC: *The Ant and the Cicada*; *Revolt. She said. Revolt again.* **Claire joined the RSC Lighting Department in 2010.**
THIS SEASON: #WeAreArrested.
TRAINED: Technical Theatre Arts, RADA.
THEATRE INCLUDES: In Claire's eight years at Stratford she has worked on a number of productions across the Courtyard, RST, Swan, TOP, UK and international tours and transfers, but her highlights so far include: Lighting Re-lighter and Programmer on *A Midsummer Night's Dream: A Play for the Nation*, Lighting Programmer on *The Tempest* (Stratford); Lighting Programmer on *Julius Caesar* (Stratford/UK and international tour); Lighting Re-lighter on *The Rape of Lucrece* (Stratford/UK, Ireland and international tour); Lighting Programmer on *Wendy & Peter Pan* (Stratford, 2013 and 2015).

JULIET GILKES ROMERO
CO-CREATOR AND WRITER
RSC: Juliet is currently the RSC and Birmingham University Creative Fellow.
THIS SEASON: *Day of the Living*.
Juliet is a playwright and journalist. She has reported for the BBC from countries including Cuba, Ethiopia, Haiti and the Dominican Republic, and for Sky News International.
WRITING INCLUDES: For theatre: *Upper Cut* (Southwark Playhouse); *Razing Cane* (shortlisted for the Alfred Fagon Award); *One Hot Summer* (radio play, aired as an Afternoon Play on BBC Radio 4); *Bilad Al-Sudan* (Tricycle. Part of a season about the genocidal conflict in Darfur). In 2009, Juliet won the Writers' Guild of Great Britain Best Play Award for *At the Gates of Gaza*. Juliet is under commission to the RSC and Eclipse Theatre, and is also writing a new musical with composer Tim Sutton. Juliet is also writing a pilot for a limited TV mini-series.

KATE GODFREY
COMPANY VOICE AND TEXT WORK
RSC: Kate is Head of Voice, Text and Actors' Support. *Twelfth Night, Julius Caesar, Antony and Cleopatra, Titus Andronicus, Coriolanus, The Tempest, King Lear, Hamlet, Cymbeline, Henry V, King & Country Cycle.*
THIS SEASON: *Romeo and Juliet, Macbeth, #WeAreArrested, Day of the Living.*
TRAINED: Central School of Speech & Drama.
THEATRE INCLUDES: Kate was a member of the voice faculty at the Guildhall School of Music and Drama for 20 years and an associate of the National Theatre's voice department since 2001. *One Man Two Guvnors, Dara, 3 Winters, Man and Superman, Three Days in the Country, The Red Lion, War Horse* and the Alan Bennett plays *People, The Habit of Art* and *The History Boys* (National Theatre). She has worked on numerous productions in London's West End, and with rep companies such as Chichester Festival Theatre, Manchester Royal Exchange and Sheffield Crucible. She has also coached Japanese actors and directors in Kyoto and Osaka.
FILM INCLUDES: *Callas Forever, The December Boys, Victor Frankenstein* (with Daniel Radcliffe).

NYASHA GUDO
ASSISTANT DIRECTOR
RSC DEBUT SEASON: *Day of the Living.*
TRAINED: A Director from Birmingham, Nyasha started as a Director at Birmingham Rep as part of the RTYDS Introduction to Directing Scheme, and subsequently on their Foundry Programme for actors.
THEATRE INCLUDES: As Assistant Director: *The Norman Conquests* (Chichester Festival Theatre); *The Meeting* (Birmingham Rep); *Love* (National Theatre). As Director: *20B* (mac Birmingham); *The Best People, A Twisted Beauty* (Birmingham Rep). He was Associate Director for the National Caribbean Heritage Museum and Furnace, a community project by Birmingham Rep. Recently Nyasha has been researching process and technique as a director training with Peter Brook and Lightpost Theatre Company.

PIPPA HILL
CO-ADAPTOR & DRAMATURG
RSC: *A Christmas Carol, The Earthworks, Vice Versa, The Hypocrite, The Seven Acts of Mercy, Fall of the Kingdom, Always Orange, Queen Anne, Don Quixote, Hecuba, Oppenheimer, The Christmas Truce, The Roaring Girl, The Ant and the Cicada, I Can Hear You, Wendy & Peter Pan, The Empress, The Thirteen Midnight Challenges of Angelus Diablo, Here Lies Mary Spindler.*
THIS SEASON: *#WeAreArrested, Miss Littlewood.*
Pippa Hill is the Literary Manager at the RSC and oversees the commissioning and development of all of the Company's new plays, adaptations and translations. She also works closely with the creative teams preparing the texts for the classical repertoire. She was previously the Literary Manager at Paines Plough running three nationwide writing initiatives designed to identify and develop new playwrights.

SOPHIE IVATTS
CO-ADAPTOR AND DIRECTOR

RSC: As Associate Director: *A Midsummer Night's Dream: A Play for the Nation*. **As Assistant Director:** *King John*.

THIS SEASON: *#WeAreArrested*.

TRAINED: Sophie grew up making amateur theatre, and after studying foreign languages and literature, she trained through various artist development schemes and traineeships, fringe projects and assistant directing. In 2016/17 she was the Clore Fellow for theatre.

THEATRE INCLUDES: As Writer and Director: *I Heart London* (Old Red Lion/Hen & Chickens, London). As Director: *Live from Frome: A Verbatim Mandate for Art* (Works Canteen, Frome); *The Big Four Oh* (Young Vic Directors); *Got It In One* (Old Red Lion); *It Falls* (Theatre503). As Resident Director: *The Curious Incident of the Dog in the Night-Time* (Gielgud for the National Theatre). As Assistant Director: *Belongings* (Hampstead Theatre Downstairs/Trafalgar Studios); *Cinderella* (Oxford Playhouse).

JON LAWRENCE
SOUND DESIGNER

RSC: *I Can Hear you*, *This is Not an Exit*, *The Famous Victories of Henry V*. Jon joined the RSC in 2011 and has operated many shows, including taking the 2012 *Julius Caesar* on regional/international tour. He has moved shows to Newcastle Theatre Royal and was involved with the West End transfer of *Oppenheimer*. He's also taken the *King and Country* tour to China and America in 2016 as well as the 2018 *Hamlet* which ended at the Kennedy Center in Washington DC.

THIS SEASON: *Day of the Living*.

OTHER THEATRE: *Oliver the Musical*, *Sweeney Todd* (Stratford Music Theatre Company).

INGRID MACKINNON
MOVEMENT DIRECTOR

RSC: *Kingdom Come*.

THIS SEASON: *#WeAreArrested*.

TRAINED: Ingrid holds an MA in Movement: Directing & Teaching from Central School of Speech and Drama.

THEATRE INCLUDES: Ingrid Mackinnon is a London based movement director, choreographer, teacher and dancer. Movement direction credits include: *#DR@CULA!*, *A Midsummer Night's Dream* (Central School of Speech and Drama); *Fantastic Mr Fox* (associate. Nuffield Southampton/national and international tours); *The Headwrap Diaries* (assistant choreographer. Uchenna Dance/national tour); *Barbarians* (assistant. Young Vic); *Our Mighty Groove* (rehearsal director. Uchenna Dance). Ingrid is Head of Dance at Wac Arts.

MATT PEEL
LIGHTING DESIGNER

RSC: Matt is a Senior Lighting Technician in the RSC Lighting Department. **As Lighting Designer:** *Kingdom Come*, *Always Orange*, *Pericles*, *Song of Songs*, *Musicals Celebration*, *Silence* (TOP/Arcola); *Dr Foster* (TOP/Menier Chocolate Factory). Relighting on: *Hamlet* (tour) *Twelfth Night*, *The Tempest* (Roundhouse), *The Canterbury Tales* (tour), *King Lear* (international tour).

THIS SEASON: *Day of the Living*.

OTHER THEATRE: As Lighting Designer: *Eden's Empire* (Finborough). Relighting: *Arthur and George* (Birmingham Rep). As Assistant Lighting Designer: *Disney's The Lion King* (Scheveningen/UK tour); *Mamma Mia!* (Moscow).

ANDREA PELÁEZ
MOVEMENT DIRECTOR
RSC DEBUT SEASON: *Day of the Living*.
Originally from Columbia, Andrea has worked in the performing arts industry nationally and internationally for 16 years. In 2004 she won a grant to study choreography, working with the British Council and the International Theatre Festival in Bogota. She also worked with Kneehigh, becoming an Artist in Residence in 2009, and with companies such as Akram Khan Dance Company and Blind Summit, and the film choreographer Francesca Jaynes.
WORK INCLUDES: As performer: *The Muppets Most Wanted*, *Avengers Age of Ultron*. As Choreographer and Movement Director: creator of *One Day One Dance* (with English National Ballet and Flawless. London O2 Arena). As Dance Consultant: *Lee Evans' Barking in Essex* (West End); US TV series *Single Ladies*; *Macbeth* (National Youth Theatre, West End); *Country Wife* (Central School of Speech and Drama); *Lady Precious Stream* (China Changing/South Bank Centre); *Heads Will Roll* (Told By An Idiot). Andrea has taught movement/dance at Guildhall Music School, RADA, University of East London, Arts Educational and Central School of Speech and Drama. She is the Co-Artistic Director of the Unesco award-winning company, Salida Productions.
OTHER: Andrea has judged for Columbia Ministry of Culture's National Dance Prize in 2014, and in 2015 she joined Fox Television's *Bailando con las Estrellas* (*Strictly Come Dancing* franchise) as a judge.

RACHAEL SAVAGE
MASK DIRECTOR
RSC DEBUT SEASON: *Day of the Living*.
TRAINED: Royal Scottish Academy of Music and Drama.
After working with a range of major theatre companies across the UK including Birmingham Rep, Northern Stage, Coventry Belgrade, Trestle and with three international theatre companies, Rachael founded Vamos Theatre in 2006. As Artistic Director, she writes, directs and acts. With Vamos, she's pioneered work with the education and health sectors, led residences in South Africa and China, mask training at London Business School, created Vamos apprenticeships and driven artistic and strategic vision. Rachael has written, directed and performed all Vamos Theatre shows to date. Since creating Vamos Theatre's 2013 award-winning show about dementia, *Finding Joy*, Rachael has continued to create connections with health and social care organisations to promote the arts as a tool for change, developing performances and workshops specifically for the sector. Rachael's work in the field of non-verbal communication emphasises empathy, listening, trust and truthful connections.

OLIVER SOAMES
SOUND DESIGNER
RSC: Joining the RSC in 2012 as Production Engineer for the national and international tour of *Julius Caesar*, Oliver has since worked as Programmer, Operator and Production Sound Engineer on numerous productions in Stratford. Most recently he redesigned sound for the 2018 tour of *Hamlet*.
THIS SEASON: *#WeAreArrested*.
TRAINED: Birmingham City University.
SOUND DESIGN INCLUDES: *The Situation Room* (Oscar Mike Theatre Ltd); *You: The Player* (Look Left, Look Right); *9* (Co-designer. Chris Goode & Co); *Falling Sickness* (Upstart Theatre); *Country Music* (West Yorkshire Playhouse/tour); *Circo de la Sombre* (West Yorkshire Playhouse).

NIC WASS
DRAMATURG

RSC: *Myth, Snow in Midsummer*. Nic is Associate Dramaturg (New Work).
THIS SEASON: *Day of the Living*.

Nic was Artistic Associate at the Tricycle, establishing their first writer-in-residence, Francis Turnly, and the NW6 new writing programme. Other roles include working as deputy in the Royal Court's Literary Department, Literary Manager at Out of Joint and reading for companies/awards including the Bruntwood, Deafinitely Theatre (judge), New York Summer Play Festival, Verity Bargate and George Devine Awards. At the Royal Court, Nic worked with translators and international writers from South Korea, Poland, Uganda and the Czech Republic. Nic has worked with circus artists, storytellers and mentored writers in the criminal justice system, and was awarded the inaugural Rupert Rhymes Bursary.

THEATRE INCLUDES: *Lava* (Nottingham Playhouse Studio); *Jinny* (Derby); *The Great Wave*, *The Invisible Hand*, *A Wolf in Snakeskin Shoes*, *The House That Will Not Stand*, *Handbagged*, *Multitudes*, *Circles*, *The Dissidents*, *The Kilburn Passion*, *Come In Sit Down!*, *The Epic Adventure of Nhamo the Manyika Warrior and His Sexy Wife Chipo*, *Red Velvet* (Artistic Associate. Tricycle); *A Time to Reap*, *Vera Vera Vera*, *5,6,7,8* (Rough Cut), *Madiya* (workshop), *Dream Story* (Gate); *The Big Fellah* (Out of Joint/UK tour); *Faith, Hope & Charity* (Southwark Playhouse); *Ogres* (Ignition/Tristan Bates).

CAROLINE WILKES
ASSISTANT DIRECTOR

RSC DEBUT SEASON: *#WeAreArrested*.
TRAINING: Bretton Hall, University of Birmingham.

THEATRE INCLUDES: *Darkness Falls*, *The Soul in the Machine* (Saltmine/national tour/Edinburgh Fringe); *Open Doors* (Women&Theatre); *Starting Out* (Birmingham Rep/Hackney Showroom/WOW Festival, Southbank); *For the Past 30 Years* (co-director. Women&Theatre/Birmingham Rep); *The Mother* (assistant director. Birmingham Rep).

OTHER: Caroline has directed a number of large-scale community projects with casts of over 50 actors. She is an artistic associate at Birmingham Medical School (Psychiatry) developing podcasts and creating theatre projects as part of their psychiatry course. Caroline has curated and directed festivals of new writing as well as directing more than 30 devised theatre productions. She has lectured in community theatre at Leeds University and guest directed productions there.

I am delighted that this Mischief Festival is premiering two pieces which speak of our right to free speech and our right to protest. As a young woman, I saw miraculous leaps forward towards freedom; the Berlin wall came down, Nelson Mandela was released and, in China, the horrors of Tiananmen felt they might at least herald a more progressive time. I did not think that in my lifetime we would see increasingly regressive regimes across the world, which would brutally threaten that freedom. *#WeAreArrested* by the courageous journalist Can Dündar, adapted by Pippa Hill and Sophie Ivatts, tells of the deeply challenging changes in Turkey in recent years, and *Day of the Living*, co-created by Darren Clark, Amy Draper and Juliet Gilkes Romero, explores the energy and spirit of young students in Mexico and the appalling mystery of their disappearance. Both pieces feel urgent and brave.

Erica Whyman, Deputy Artistic Director, May 2018

WE ARE ARRESTED

BY CAN DÜNDAR
ADAPTED BY PIPPA HILL AND SOPHIE IVATTS

FROM THE ENGLISH TRANSLATION BY FEYZA HOWELL

We Are All Arrested

Welcome to this temple to theatre. When I first stepped in here, it was in a mood of curiosity about what awaited me on the stage. This curiosity initially gave way to a strange sadness, which in turn was washed away by awe.

Curious to see how my experience would be represented;

Saddened by that representation,

And awed by the sheer eloquence of art…

It is a rare stroke of luck for a book completed in a prison cell in Istanbul to be staged in Stratford-upon-Avon a mere two years later. Allow me to extend my gratitude to everyone who made it possible, gave my book a voice, and transported it to the stage.

Allow me also to emphasise that this apparently personal experience is but a brief chapter in the mass struggle for human rights in Turkey. *#WeAreArrested* is an allegory of the imprisonment of an entire society, and not just one person. Yet it is also a tale of the resilience of an oppressed society driven into a corner. Of creating hope out of nothing. And every word is true.

This adaptation shrewdly replaces proper nouns with generic terms in order to transform my experience into a universal truth. We are all arrested, in a manner of speaking, in Europe faced with escalating populism, in the US where the president ignores the freedom of the press, and in a world with an increasingly poor human rights record. This play therefore has the potential to be staged as a documentary in many parts of the world.

I would like to note at this point that the newspaper in the play is Turkey's oldest and most prestigious broadsheet, the *Cumhuriyet* (Republic) that has, for nearly a century, upheld the values of the republic, democracy, secularism and freedom, often under the toughest conditions. Many of my colleagues, friends and lawyers who you will see in the play have since been arrested and are facing lengthy prison sentences. But they have never once given up the fight for freedom of press.

What might well be taken for granted by Western audiences is in fact a right that countless activists elsewhere risk their lives to defend. This play serves as a reminder that this precarious freedom deserves to be treasured… Just like the importance of

international solidarity...

I was still under the grip of those dark days conjured so vividly on stage as I walked out of this temple to theatre. A few hundred yards down the road, my feet took me back to the sixteenth century. I entered the church nearby and stood before the tombstone to pay tribute to the writer whose words still etch themselves into our hearts 400 years on.

And I took my hat off to the power of words once again:

Our tormentors will vanish from the annals of history.

But art and literature will survive for ever. And articulate our dream that the entire world will one day shout, 'We are free!'

Can Dündar, 2018

For Can, Ege and Dilek

Characters

CAN

ACTOR 1/ GUNMAN

WIFE /CEO/ GRANDMOTHER/MOTHER/ ESTATE AGENT/
PSYCHOLOGIST/ ENSEMBLE

SON /GUL/ NEWS EDITOR/ PROSECUTOR/ ENSEMBLE

CAN is pronounced 'Jan'.

When CAN speaks, it is direct address to the audience. Speech marks delineate where he is conjuring up a scene or dialogue from memory.

CAN does not see or acknowledge ACTOR 1 until the end of the play. There is a disturbing sound effect of white noise or radio interference whenever we become aware of ACTOR 1. We might hear snatches of the international right wing media mingled into the white noise.

Cumhuriyet

CUMA 29 MAYIS 2015

MİT TIR'larının savcılık emriyle jandarma güçleri tarafından durdurulduğu görüntüler daha önce medyada yayımlanmıştı.

Cumhuriyet tarafından ele geçirilen görüntülerde çelik kutuların yetkililer tarafından nasıl açıldığı da yer alıyor.

Üç kamera tarafından yapılan çekimlerde açılan çelik kutuların içinde çok sayıda silah ve mühimmat olduğu ortaya çıkıyor.

İçişleri Bakanı Ala, 'İçindekileri biliyor musunuz' demişti. Artık biliyoruz

İşte Erdoğan'ın yok

CAN DÜNDAR

dediği silahlar

Cumhuriyet, 19 Ocak 2014'te ihbar üzerine durdurulan TIR'ların görüntülerine ulaştı:

MİT TIR'LARI AĞZINA KADAR SİLAH DOLU

SAVCI ENGELLENDİ

ADANA Savcılığı bir ihbar üzerine Adana Ceyhan Sürücü çiçeğinden üç TIR'ı durdurmuş, operasyon MİT ile savcılığı karşı karşıya getirmişti. Savcılığın 'silah taşınıyor' gerekçesiyle durdurduğu TIR'lara el koyması MİT ve valilik emrindeki polisler tarafından engellenmiş, Erdoğan devreye girerek savcılığın işlem yapmasına izin vermemişti.

SURİYE'YE SİLAH

OLAYIN medyaya yansıması üzerine dönemin Başbakanı Erdoğan ve İçişleri Bakanı Ala, TIR'ların hükümetin bilgisi dahilinde Suriye'deki Türkmenlere gıda yardımı götürdüğünü savunmuştu. Cumhuriyet'in ele

MİT TIR'INDAN ÇIKAN SİLAHLARIN DÖKÜMÜ

1000 HAVAN

1000 TOP MERMİSİ

50 BİN MAKİNELİ TÜFEK MERMİSİ

30 BİN AĞIR MAKİNELİ TÜFEK

CAN walks onto the stage and greets the audience:

CAN: Good evening everybody, thank you for coming.
I used to have a very normal life. I lived with my wife. And our son. And our dog, Cinammon. I had a lovely home. A job that I loved. I'd have a glass of wine with friends after work. Life was good. I didn't realise how good, until all those things were taken away.

They say the best stories are always written facing the most magnificent views. But I have discovered the opposite to be true: the imagination, when it meets a wall, can soar to see what lies beyond.

I tell you this story tonight, in the hope that tomorrow we will be able to say:
'Those were dark times. They are gone now.'

What follows, in my own words, is a truthful description of the events that began three years ago and completely changed my life.

We become aware of someone watching us and CAN. He's in the auditorium with us. He is ACTOR 1. He is not on the stage but somewhere in the audience. CAN does not appear to see him, but maybe he can hear him?

ACTOR 1: Crime.

CAN: Thursday, 28 May, 3pm.

An emergency meeting is called on the fifth floor of our national newspaper where I am the editor in chief.

We are here to discuss a video that has been delivered to the paper this morning.
The footage shows an articulated lorry belonging to our national intelligence agency being intercepted by armed police.
An altercation ensues.
The police officers carry out a search. The steel doors open to reveal boxes of medical supplies. But as the police dig deeper, they find heavy artillery underneath: mortar rounds, grenade launchers.

This footage, filmed by the police, is the crucial evidence we need to prove a story we've been investigating for months. It leaves no room for doubt: our country is secretly arming extremists in a foreign civil war. It's one of the biggest stories the paper has ever uncovered. It is a scandal of global proportions and there's a general election just days away.

A newspaper editor receives hundreds of tips and documents every day.
You have to question their veracity and the motivation of the bearer.
The risk of being manipulated is high.

That's when you ask yourself two questions:
Is this document genuine?
Would it be in public interest to publish it?

If the answer to both is 'Yes', then hiding it in a drawer is a betrayal of your profession. But the stakes are high.

NEWS EDITOR: 'The government has denied involvement in this war over and over again – and now we've got proof they are lying! And not just here – they are lying publicly to international heads of state! It's against everything this country is meant to stand for. It's clearly in the public interest – we have to publish this.'

CEO: 'I'd recommend not publishing, it's too dangerous. The government are out for blood. They are already claiming that the search of the lorry was illegal. This president is capable of anything.'

NEWS EDITOR: 'Look we're not committing any crime – we're about to expose one! The government have lied and acted illegally. They've made a major political decision that could change the course of the country's history and it hasn't even been debated in parliament – no one knows! The public have to know before they vote next week!'

CEO: 'It has to be your decision. You're the one they'll go after.'

CAN: 'Let's run with it. What's the worst case scenario?'

CEO: 'If we break the story now, they'll raid the newspaper tonight, seize the papers, and arrest you,'

CAN: 'OK. So let's wait until tomorrow morning to run the story – we'll run teasers on the website but we won't put the full story online until the morning edition has gone out. That

way we minimise the risk of a raid before we publish. I'll write a leader explaining to the readers our decision. OK?'

CEO: 'OK, but don't risk being arrested. Go abroad. Tonight.'

CAN: While I write the leader for the story, my assistant desperately searches for a flight to get me out of the country.
There's one seat left on a flight leaving the country tonight and I think: at least I can visit my son – he is at university there.
Just then, I'm shown a mock-up tomorrow's front page. It's a still from the video showing all the weapons in the lorry with the headline: 'The Weapons the President Denies'. It is stunning.
I leave the paper and go home in the afternoon, surprising my wife with my early return. The sun is about to set.

We have a glass of wine on the terrace as I give her the news.

CAN: 'I have to leave.'

WIFE: 'When?'

CAN: 'Tonight.'

WIFE: 'Do you think the house will be raided?'

CAN: 'I don't think so, but it's not impossible. Don't stay at home tonight.'

WIFE: 'Perhaps you shouldn't publish?'

CAN: I don't reply.
I'm at the airport two hours later.
I don't like being away on a night like this.
Will the print-run be seized before we can get the papers out?

Will they raid the house, looking for me?
I'm hoping this'll be a brief trip, but could it
turn into a long exile instead?
Just then I get a text which puts a smile on
my face, in spite of it all. It's from my son.

SON: *My best mate's coming to visit. So happy.
The dishes needed doing, Dad!*

I board the plane at 11pm.

I try to draw on George Orwell for moral
support:

'In a time of universal deceit, telling the truth
is a revolutionary act.'

ACTOR 1: Threat.

CAN: The story explodes overnight.
 The chief prosecutor launches criminal
 proceedings against me.
 The CEO of the paper calls me first thing:

CEO: 'It's a ridiculous allegation, but they are
 trying to get you on a charge that carries a
 life sentence. You can't come back.'

CAN: 'Why? What's the charge?'

CEO: 'Espionage. Revealing state secrets.'

CAN: Espionage?
 In the middle of this uproar, I meet my son.
 One single hug, and all the gloom vanishes.
 We take a long stroll together.
 But my phone never stops ringing, constantly
 dragging me back to reality; the tranquil
 chatter between father and son interrupted,
 as spectres of weapon-laden lorries roll
 through the gentle city park.
 It feels wrong to be standing at a safe
 distance. But everyone back home is telling
 me to stay away.

 Then on 31 May during supper with my
 son, I receive a text message from our News
 Editor.

NEWS EDITOR: *The President's threatening you on national
 T.V.. He says: The journalist who wrote this
 is trying to tarnish our country. I'll make
 him pay a heavy price. I'm not letting him
 get away with it. I'll be taking legal action
 against him.*

CAN: For the first time in our country's history, the
 president is personally, publicly attacking a
 journalist. Such fury can only come from a

greater fear of more revelations – what else is
he hiding?
I read the text out to my son
'How should we respond?'

SON: 'Defiantly.'

CAN: I compose a tweet, throwing the president's
words back at him:
***The person who committed this crime will
pay the price. We're not letting him get away
with it.***

The next day the front page of the morning
edition arrives by email. My entire editorial
staff have issued a defiant headline:
Journalists – Guilty as Charged', with
headshots of every single one of them on the
front page.
I can't stay any longer – I have to stand by
them.
I book a ticket for the next flight home.
I say good-bye to my son and I give him
a copy of the entire contents of my laptop
for safekeeping. I'm setting off into the
unknown.
'What message shall I give to your mother?'

SON: 'Tell her I'm proud of my dad.'

CAN: The enormity of what we've done sinks in
when I board the plane home. The other
passengers cheer, shake my hand, give
me high fives. I read about myself in the
headlines.
I ask myself if I'm afraid. But I know
that fear breeds silence. And we have a
responsibility to speak out before silence
takes hold.
I step off the plane at the airport of my home
town and walk up to the immigration desk.

The officer looks at my passport first, then
at my face… He smiles, stamps my passport
and waves me through.

*We become aware of ACTOR 1 here. He is moving through the audience,
watching us watching CAN.*

ACTOR 1: Award.

CAN: The police raid I expect at any moment never materializes. The general election that week brings new hope. The public, gagged in the street, speak at the ballot box and deliver a hung parliament. Having lost their parliamentary majority, the president's party struggle to form a coalition government, and we are relieved that, for now at least, they have more than enough to worry about than to pursue a court case against me.

Our newspaper is showered with international awards for courageous journalism. But the international attention these awards bring is bittersweet for us because it makes it increasingly dangerous to publish our stories and we are becoming a target.

In July the police arrest a suicide bomber carrying the address of our office in his pocket. The street is closed to traffic. We evacuate the building and leave through a police barricade after dark. We entrust the paper to the police tank waiting at the gate. It looks like a war zone. Friends and family are pressing me to buy a gun, to get a bodyguard or a bulletproof car.

That summer, as I travel abroad to collect our awards, I can feel the rest of the world holding our hands. But I realise that rest of the world is in no fit state to help us. From city to city, country to country, Europe's cathedral squares are watched over by armed patrols. The threat of terror looms large.

Fear, the sickness of our age, has captured
the elderly continent.
At one of the award ceremonies, Reporters
Without Borders reason with me:

ENSEMBLE: 'We're worried about you. If you stay here
with us, we can help you. Don't go back.'

CAN: For many years I've heard tales of exile,
and even covered some in documentaries
I've made. Most are unhappy stories;
homesickness debilitates many and has even
killed a few.

I can't accept being made to flee like a
criminal.

Back at home, my own country is on fire.
All summer, suicide bombers flood our city
squares with blood.
In the grip of this nightmare the President
holds a blunt knife at the throat of society
and whispers, 'Vote for us, and this will stop.'
A snap general election is called by the
president in November. His party polls five
million new votes. It is a landslide.
As we watch the early results come in on the
night of the election, no one in the office says
a word.
We are weary and unarmed.

My son phones. He's glued to his T.V.
screen:

SON: 'It's heartbreaking to watch our homeland
slip away like this'

CAN: My mother rings: she knows my phone is
tapped and chooses her words carefully:

MOTHER: 'You know I'd never ask why if anyone wanted to live elsewhere…'

CAN: As we prepare the front page at work that night my assistant editor whispers,

NEWS EDITOR: 'I think you should leave tonight. Out of the country. They'll come for you now. They'll come for you in the morning.'

CAN: The fear is palpable.
I get home in the early hours.

WIFE: 'Perhaps you ought to leave.'

CAN: 'I've done nothing wrong.'

This is the moment the idea that I might actually go to prison becomes a real possibility.

We've had our awards. Now it's time for our punishment.

ACTOR 1: Punishment.

CAN: *'Someone must have been telling lies about*
 Josef K., for one morning, without having done
 anything wrong, he was arrested.'
 That's how Kafka starts *The Trial.*
 That's what I'm thinking about on the
 morning of Tuesday 24 November, when I
 find the phone on my office desk flashing
 with a new voicemail:

ENSEMBLE: ***The Chief Prosecutor has summoned you to***
 give a statement at 11am on Thursday, 26
 November.

CAN: The president has just approved his new
 cabinet and the message on my answerphone
 is the first act of his new government.
 We gather in the big meeting room on fifth
 floor at 3.45.
 Our CEO bursts in.

CEO: 'The charges are astonishing! Obtaining and
 disclosing confidential state documents with
 the purpose of political or military espionage
 and aiding and abetting an armed terrorist
 organisation.'

CAN: 'Aiding a terrorist organisation? Which one?!
 Who would believe we're spies; let alone
 terrorists?'

ENSEMBLE: 'No one will believe it – it's nonsense!'

ENSEMBLE: 'You can't put anything past this president'

CAN: 'OK, so give me the best and worst case
 scenarios?'

CEO: 'Best case is they release you on bail, with
 a ban on foreign travel. But because the

	charges relate to national security, the risk of a pre-trial detention is pretty high.'
CAN:	'How long do you think I could be held for?'
ENSEMBLE:	'A Year? Three years? Who knows? You should leave the country. The law's no longer impartial. The courts are all under government control. No one who goes in comes out.'
ENSEMBLE:	'You won't go to prison! You can't be convicted for revealing an open secret – the president has just admitted it on national T.V.! He's just verified our story!'
CEO:	'You're wrong. They'll set you up with fake evidence linking you to this terrorist organization. Then they'll delay a proper trial and put you in prison indefinitely. '
ENSEMBLE:	'I agree. Under this new government, it would actually be better to get you a conviction so we can appeal to the Constitutional Court or the European Court of Human Rights.'
CAN:	Truly Kafkaesque...

I decide that I will go and offer my statement to the chief prosecutor, come what may.

I'm alarmed to learn that our Bureau Chief, Gul, from our regional headquarters, who published an inventory of the weapons in the lorry, also has an answerphone message summoning him on the same day as me.

The following evening after work a large crowd of us stroll over to our favourite local restaurant. We laugh and chat and drink.

We raise our glasses to all our friends at that table. We all wonder if it might be the last drink we'll have together for a long time. That night at home, I choose the books I want to take to prison just in case. My wife and I avoid discussing it. We know hard times are ahead. But we do believe we will overcome. This too will pass.

The following day is 26 November.

We will be celebrating our twenty-eighth wedding anniversary.

ACTOR 1:	Court.
CAN:	When I was a child, my grandmother always started with a kindly,
GRANDMOTHER:	'oh,'
CAN:	And
GRANDMOTHER:	'God is great, son,'
CAN:	No matter what the topic was, or how important or trivial. Her unshakeable belief would make you assume that no evil deed would ever be left unpunished and that no injustice would prevail upon the earth.
GRANDMOTHER:	'God is great!'
CAN:	Consoles the victim and threatens revenge upon the vain. She would stroke my face and say,
GRANDMOTHER:	'God is great,'
CAN:	And I would be comforted. But as I grew up, I had questions: 'If he's that great, why doesn't he break thieving hands? Why doesn't he return my marbles and punish the kid who stole them? Why does he withhold his mercy?' Whenever I asked these questions, she would shush me with a,
GRANDMOTHER:	'Repent!'
CAN:	And shelter in the only justice she trusted:
GRANDMOTHER:	'God is great!'

CAN: I ring my mother on the morning I'm due in
 court, Thursday, 26 November.

MOTHER: 'God is great, son,'

CAN: She says.
 It's raining.
 I put on my smartest velvet jacket and
 my favourite shirt. Suitable for defeat or
 celebration.

 The Justice Palace is filled with friendly
 faces: writers, journalists, MPs, and my
 colleagues.
 I give a short statement at the door:

 'We're not spies, traitors or heroes; we're
 simply journalists. We're here to defend
 journalism and the public's right to be
 informed. We won't be intimidated…
 We will stand up and defend our words.'

 Gul and I are interviewed separately.
 I step into the prosecutor's office at 11.20.
 The prosecutor is cheerful and impeccably
 courteous.

 As we sip our teas, he points to the thick blue
 folders on the filing cabinet.
 They contain a 10,000-page report on the
 activities of the political pressure group
 we are accused of colluding with. A group
 the president now describes as a terror
 organisation.

 I'm curious to see how on earth he'd connect
 them with me.
 It seems I aided and abetted the group
 'unwittingly.'

PROSECUTOR: 'You have divulged state secrets.'

CAN: 'So it is true then: the lorries were shipping arms and it's a state secret.'

PROSECUTOR: 'Whose right is it to decide what can be known, and what cannot be known? The government's, of course.'

CAN: 'And what if the government were committing a crime? What if that crime was concealed under the label of 'state secret'? Who would monitor that? The National Intelligence Agency was acting beyond its legal authority. They were committing a crime by smuggling weapons illegally for a war which we had no democratic mandate to involve ourselves in – and absolutely no transparency about who those weapons were intended for. And the government lied about it: to us and to the rest of the world.
It is a journalist's duty to expose any crime – regardless of who the perpetrator is.
That's the difference between a journalist and a civil servant.'

PROSECUTOR: 'And do you think an intelligence agency can admit that it's shipping weapons?'

CAN: 'Of course not. But neither could any journalist ignore it'

PROSECUTOR: 'So you think anything could be news then? You know about the German Chancellor's naked photos taken when she was very young? The German papers didn't publish them. Would you publish my naked photo if you found it? Are there no limits?'

CAN: 'Public interest defines the limits. There's absolutely no public benefit to publishing naked photos of Angela Merkel – or you! But it is in the public interest to know if the

45

state is committing a crime. And if I uncover one, it is my duty to expose it. What if we're dragged into this war, without Parliament's knowledge, who's going to check it? Who's going to warn the public? Don't Parliament and the public have a right to know?'

CAN: Several cups of tea later, the prosecutor still doesn't look convinced:

PROSECUTOR: 'The interception of those lorries was a trap set for our country. A trap set by a rogue terrorist group.'

CAN: 'And we belong to that group do we?'

PROSECUTOR: 'We'll be laughed out of court if we try to claim that.'

CAN: 'Sir, this group you are suddenly so anxious about is an organization our newspaper has consistently investigated and openly criticized for years. Surely the government cannot accuse us of conspiring with them? Where's your evidence?'

PROSECUTOR: 'Is this your telephone number?'

CAN: 'Yes.'

PROSECUTOR: 'Did it belong to you between 20 and 30 May?'

CAN: 'Yes.'

PROSECUTOR: 'Do you know these two people or recognize their phone numbers?'

CAN: 'No.'

PROSECUTOR: 'They were recorded exchanging messages on 28 May discussing the publication of your report. Are you aware of this exchange?'

CAN: 'No.'

PROSECUTOR: 'OK. That will be all.'

CAN: 'Really? That's your evidence? No fake telephone conversations? No faked money transfers into hidden bank accounts? Are you seriously planning to arrest me on an allegation of espionage based on a Twitter exchange between two people I've never heard of?'

They have nothing.
Not a shred of evidence.

Gul and I both emerge smiling from our interviews.

'They've got no case against us,' we tell friends waiting at the door.

We sit down on the floor with our friends and lunch on toasted sandwiches and yoghurt drinks.

Suddenly a clerk emerges.

ENSEMBLE: 'You are both summoned to court for arrest.'

CAN: A cloud of bewilderment sweeps through the hallways.
How can this be happening?
My telephone is ringing non-stop.
Voices of outrage rail from all quarters.
I compose a Tweet:
We are arrested.
But I stop short of sending it.
We walk into the highest court in the land and our statements from the prosecutor's office are read out to the judge. He then announces our arrest, speaking for about ten

47

seconds before he leaves the courtroom.
I hear a yell from somewhere behind:

ENSEMBLE: 'Shame on you!'

CAN: I hit "Tweet": ***We are arrested***.
The courtroom is in uproar. Suddenly I'm in
front of a T.V. camera:

'Don't be discouraged. Whether we are
inside or outside, it makes no difference. We
will continue the struggle.'

I embrace my wife and whisper 'Happy
anniversary.'

*We become aware of ACTOR 1 here, still gradually making his way
toward the stage.*

ACTOR 1: Road

CAN: Six or seven anti-terror squad officers escort
 me and Gul down to the car park.
 We say our goodbyes.
 We set off, down the road I walk daily on my
 way to the newspaper.
 Familiar buildings, shops, pavements and
 people all sweep past the car windows. It all
 looks different tonight.
 For the first time in my life, I try to carve
 familiar images into my mind. I don't know
 when I'll see them again.

 An hour and a half later, the prison appears
 on the horizon. We cross beyond the prison
 wall at midnight. The soil ends.
 This is a land of concrete and iron. Walls and
 barbed wire everywhere.
 Watchtowers, charmless single story
 buildings connected by spot-lit narrow lanes
 leading to deserted courtyards painted dirty
 yellow.
 How long can they actually keep us here? It
 is impossible to believe we were to be held
 in such a high security prison without even
 having been to trial.

 We stop at the last courtyard and get out of
 the car.
 A vast iron door opens.
 We step in. Gul is taken away as we are led
 to our cells.

 Now the key.
 Then the bolt.
 And finally the screw iron handle.
 My solitary confinement begins.

ACTOR 1: Night

CAN: Can you go back a century in one step?
Tonight I have. Alone in a cell in prison.

None of the objects that have entered our
lives in the last century are here.

No mobile phones or computers, no internet.
No washing machine, dishwasher or fridge.
No T.V., radio, or table lamp.
Not even a rug, curtain, armchair or teapot…

They are going for a minimalist look. I take
in the cell like a flat-seeker, unconvinced by
the offerings of a pushy Estate Agent:

ESTATE AGENT: 'A white plastic table. A white plastic chair.
Three iron beds. Three metal beds. One
kitchen worktop. A steel cupboard on the
worktop. Surprisingly spacious. A two-story
villa of twenty-five square metres. A seven-
pace by seven-pace room downstairs.
There's a walk-in shower room with toilet.
Another brown iron door opposite the
entrance opens to the courtyard; although,
sadly, it is locked at this time.'

CAN: The room and I stare at each other.
My black velvet jacket looks the white plastic
chair up and down, as if to say, 'I must have
got the wrong wedding.'

I open the toilet door: as tiny and squalid
as one you'd find in a petrol station. The
shower is a step away from the squat toilet.
And the washbasin, another step away.

There's a mirror taped to the wall.
A two-inch gap between the iron door and
the floor, and I can smell sewage.
The stairs lead up to three battered old beds,

bolted to the floor.
'Thankfully I won't be staying long,' I think.
Then laugh at myself.

Everything echoes here.
Water roars like a waterfall, a door slams like
a thunderclap.
I switch off the fluorescent light.
The floodlight from the yard falls into the
room, diced into a grid by the window bars
that cast faint shadows on the beige floor tiles.
It looks like moonlight in the darkness.
Good job I've taught myself to dream.

ACTOR 1: Daytime.

CAN: Next morning, I'm still rubbing my eyes
 when four silhouettes in navy blue uniforms
 climb upstairs, look at me and leave,
 unlocking the door to the yard as they go.

 Now the cell looks like a concrete matchbox,
 with its tray pushed out.

 I step out into the yard. It's a sunless,
 soilless and flowerless garden enclosed
 by a ten-metre high wall rising to cloudy
 skies, wearing a crown of barbed wire. The
 familiar, vast, bright blue countenance of
 the sky is hemmed in between these wires. I
 inhale that handful of sky.
 Every eight paces, you meet a wall.

 Gul has to be beyond the wall, but it's
 impossible to hear or see him.

 I'm just thinking I could do with a cup of tea,
 when I hear a noise. Something drops into
 the yard.

Three red apples fly over the wall.

ENSEMBLE: 'Welcome!'

CAN: It is a gift sent from the neighbouring yard.
 I'm staring up into the air, trying to work out
 which direction it had come from, when a
 second parcel flies over the barbed wire.

A bottle full of tea flies in.

 A plastic soda bottle wrapped in newsprint.
 And inside… Yes! Piping hot tea, with some
 sugar cubes too…

ENSEMBLE: 'Welcome.'

CAN: 'Thank you. Thank you; who are you?'

 He tells me his name, but I can't make it out.
 The wall breaks up the sound.

ENSEMBLE: 'Speak through the grate.'

CAN: I realise it's the editor in chief of another
 newspaper. He and his deputy were brought
 to the prison a month before Gul and me.

ENSEMBLE: 'The papers have covered your arrest in
 great detail. Massive outrage. I heard protest
 marches would take place today.'

CAN: 'Thank you, Thank you, wonderful news!'
 Immediately, I feel less alone.
 I save one of the apples and try to lob the
 other two to Gul in the same way.
 In vain. My parcel doesn't clear the barbed
 wire.
 As I practise my catapulting technique, a
 final gift arrives from the other wall:

A newspaper flies in.

 It is today's edition of the paper. Now that is
 a miracle.
 'Media's Black Day' is the headline with a
 photo of my wife and I at the courthouse
 yesterday. I wonder how many of the other
 papers have dared to report the story.

 Just then the heavy iron hatch of the cell
 door opens and a piece of paper appears,

A form appears.

ENSEMBLE: 'Canteen price list. Choose what you want
 off the list. You can spend up to fifty per
 week'.

CAN: Over 350 items were listed on the form.
 'How do I get money?'

ENSEMBLE: 'Ask your visitors to deposit it.'

CAN: 'Can I have newspapers and a T.V.?'

ENSEMBLE: 'Request them on these forms.'

CAN: And he hands me a biro and a yellow
 notepad and shuts the hatch.

A yellow notepad and a pen appear.

 I turn the order forms over – they are blank
 on the back.
 He has just given me the world.
 Pen and paper.
 My two oldest friends are now with me.
 I sit down and write my first piece for the
 paper from jail.

ACTOR 1: Writing.

CAN: Dear Friend, Here we are again, together.
 Whenever I'm in trouble, you're the first one
 to take my arm; whenever I'm happy, you're
 the first one to hug me. We've travelled so far
 together…
 You have been my comrade, my confidant,
 my everything, since that first day I put pen
 to paper.
 You're the one who felt the rush of blood, the
 first thrills of youth.
 You it was who found my first love, and my last.
 I'm so glad I chose you as my profession.
 You it was who paid the first instalment on
 my first bookcase, and the mortgage on my
 house.
 You have fed me for years and years, paid
 me a salary.
 And now we're here, locked up together.
 And you're going to reach out and grab
 me by the hand, just as you always have
 whenever I am in troubled waters.
 You will laugh and cry with me.
 You will share my solitude.
 You will write my solace and my defence.
 You put me in this cell and you will get me out.
 You will put me on a paper plane and fly me
 off to the next yard, to the world beyond the
 wire and walls, to freedom, and my loved ones.

*During this speech, CAN rips a piece of paper from the yellow notepad
and appears to magically create a paper bird or paper plane.*

ACTOR 1:	Spy.
CAN:	Any detainee who wants to see a psychologist can. I say yes out of curiosity. They lead me to a room where I sit down facing a young interviewer. She is impeccably polite.
PSYCHOLOGIST:	'Your name please? And your age?' And your profession please?' And are you here on terror or criminal charges?'
CAN:	'I'm a spy.' I say it as if I'm James Bond. She is astonished. 'I'm accused of espionage but, it seems I'm a bit of a novice. I splashed the first bit of information I got all over the front page of a newspaper, instead of passing it on to the secret service. I got caught on my very first mission. And I was locked up so I couldn't tamper with the evidence.'
PSYCHOLOGIST:	'Who introduced you to crime?'
CAN:	'My mother. You see, when I was still a baby, she read me books and that way she prepared me for crime. Then there was my primary school teacher. By teaching me to write, she had equipped me with the instrument of crime.'
PSYCHOLOGIST:	'Are you going to continue to commit crimes after your release?'
CAN:	'So it seems. I can't stop reading or writing.' We end the interview.

ACTOR 1:	Visitors.
CAN:	The iron hatch in the door opens. A voice calls in:
ENSEMBLE:	'Solicitor to see you.'
CAN:	Or,
ENSEMBLE:	'MP visit.'
CAN:	Every time I leave the cell I am subjected to a body search. Remove shoes, right one first. Bang the heel on the floor and put it back on. Then the left. Bang the heel on the floor and put it back on. Walk. Take sixty steps. Halt. Repeat. The visit room is like an aquarium. Glass cubicles are arranged in a row like a train with a glass divide between inmate and visitor. Handsets to talk through. In this fish tank, I entertain over 200 lawyers and politicians during my detention. My visitors make assurances:
ENSEMBLE:	'I will discuss this with the Prime Minister.'
ENSEMBLE:	'We will launch an appeal against your arrest in the Criminal and Constitutional Courts'
ENSEMBLE:	'We will do everything we can to get you and Gul out of here'
CAN:	Give me survivor's tips:
ENSEMBLE:	'Look after your health. Try not to catch a cold. Fill a plastic bottle with hot water at night – use it to keep warm in bed'
ENSEMBLE:	'Make sure you work out. The yard is short; if you go back and forth, you eventually

sprain your ankles. Best to keep a circular path. At least for an hour…'

ENSEMBLE: 'Don't try to wash your clothes by hand. Put them in the plastic bowl and trample on them. "Heel-o-matic" washes really well.'

ENSEMBLE: 'The food is really greasy. Rinse it first, then reheat it in the kettle.'

CAN: My CEO visits:

CEO: 'Foreign media has covered the story. The hashtag *WeAreArrested* is trending worldwide on Twitter. Reporters Without Borders have declared you a hero and they've started a petition for your release. You know the EU Summit is scheduled for Sunday? We need to make sure you're on the agenda. You should write to all the heads of state from prison.'

CAN: Human rights and the freedom of the press sink into insignificance in the face of a flood of refugees or the lure of lucrative trade deals. I know this.

All the same, I think it's worth a try. I had already devised a number of ways to smuggle out my newspaper bulletins, despite the endless body searches.

As soon as I get back to my cell, I take her advice. The only paper I have is the pad of canteen order forms. I enthusiastically write letters to all the heads of state who will be at the summit. Twenty-eight leaders in total:

Sir/Madam, I hope your anxieties concerning the refugee crisis and trade will not stand in the way of your principles on human rights, freedom of speech…

My mind is made up:
I will transform this dungeon into a
microphone, make my voice heard as far as
it will reach.

ACTOR 1, still in the audience, may make his presence felt here.

ACTOR 1: My wife.

CAN: My wife visits.
I'm taken from my cell. Body search.
Remove shoes, right one first. Bang the heel
on the floor and put it back on. Then the left.
Bang the heel on the floor and put it back on.
Walk. Take sixty steps. Halt. Repeat.

I'm bursting with excitement.

We leap up as if we haven't seen each other
for months.
We are separated by the thick panel of glass.
Our palms kiss on either side of the window;
the kiss of our fingers leaves their mark on
the glass.
She looks so elegant, strong and determined.
She is cheerful and brave. The magnificent
firebrand I fell for as a student resurfaces at
times of crisis and is born again.
Earlier today, she addressed the crowds
outside the newspaper:

WIFE: 'We are deeply proud of this paper's integrity
and its ongoing fight against oppression.'

CAN: She gives me all the news:

WIFE: News of your arrest has spread fast, friends
have rushed over offering help. Our mothers
have both been in tears. I've consoled
countless callers who ring the house to share
their distress, I tell them to channel their
feelings into action.

There is a moment when we both realise that
in prison there is nothing more to hide. So
we enjoy this new openness.

CAN: We feel free to poke fun. 'I'll grow my beard until I'm acquitted if that's all right with you,'.

WIFE: 'Any excuse,'

CAN: She's never much liked a beard on me.

WIFE: 'I've brought you your books, and a few of my favourites too.'

CAN: The handset beeps to tell us that the hour has gone. Time's up.
I show her the tiny passport photo I've hidden in my pocket.
A photo taken in a tiny cubicle not much different from this one, our son between the two of us. A photo full of wide grins.
She looks; her eyes fill. We gaze at each other.
The line is cut. She leaves.

Back in my cell, the T.V. set arrives.
I watch footage of the protests against our arrest.
"You're not alone!" yell the banners in the streets.
It is as if a twenty-nine-channel spaceship has landed in the mediaeval décor, brightening up the dark cell with the warm glow of solidarity.

ACTOR 1: Curse.

CAN: The paper regularly try to send me a press digest, so I know what's going on in the outside world. I am used to our pro-government press inventing stories about me. I have come to expect it.

 Today, one of their tabloids runs a slur that claims I'm hiding my son's true parentage:

ENSEMBLE: ***Liberal journalist's illicit love child. What else is he lying to us about?***

 '***The whinging journalist claims he was arrested on his twenty-eighth wedding anniversary. Official records show that he married in 1991 but that his son was born in 1989, is he another man's son? For someone so obsessed with telling the truth, is this man really a liar?***

CAN: And so on. More of the same vicious mud-slinging that has gradually, somehow, become normal.
 I usually ignore it, laugh even. But today, I suffer a total sense of humour failure.
 I am livid.
 Perhaps it's because of the depravity of kicking someone when they're down.
 Perhaps, because the truth is that our son was a blessing after three heartbreaks.
 But what can I do?
 I can't send in a correction request. I can't make them stop.
 I hurl obscenities at the walls, the heavens and the city…
 I shock myself with my own fury.
 I've never seen myself like this.

It passes. I distract myself.
And I forget it a few hours later.

Then it's announced on T.V. that the
journalist behind the article has died
suddenly of a heart attack.
As though it is my curse that has killed him.
I'm suddenly scared by the power of my rage.

I forget the slurs the dead man has written
about us and address the heavens:
'God forgive his sins. Don't let me come out
of here full of vengeance.'
Just then my grandmother whispers into my ear,

GRANDMOTHER: 'God is great, son.'

ACTOR 1: Time

CAN: Outside, the weekend is a welcome break.
 Inside, it's the opposite.
 The prison goes to sleep on Saturdays and
 Sundays.
 Time, that gushes like a waterfall on visit
 days, trickles like still waters once the week
 is over.
 The voices fall silent, the canteen is shut.
 The gloom of a deserted public office settles
 into the corridors.
 As the weeks pass my sense of time becomes
 colonized.
 Telephone day.
 Visitors' day.
 Exercise day.
 Post day.
 These routines are designed to quietly
 convict you. The aim is to turn me into a lifer
 before I've even been tried. You become a
 prisoner to waiting.
 The cell is a waiting room:
 You wait for the papers to come, for the
 bread, for the yard door to be unlocked, for
 the meal, for the evening, for a match on
 T.V., for night, for morning.
 But most of all, for release.

 But on my first Saturday in prison, I'm naive
 and willful.
 I resolve to break the routine imposed upon me.
 My first act of rebellion is to target
 monotony.
 I discover that the charmless toilet-come-
 shower can be transformed into a steam
 room if I run the hot water for a couple of
 minutes – and use my imagination. And the
 bare walls become a magnificent backdrop

for performing songs in the shower.
The breakfast scheduled for 0800 can wait.
I decide that I would rather brunch instead.
But the venue looks a bit dull.
I decide I will eat 'al fresco'.
I carry the white plastic table to the yard,
deploy the duvet cover as a tablecloth. I put
on my jumper and jacket. I fold the blanket
into a cushion for the plastic chair.

I transform the tasteless food into a
sumptuous feast.

A beautiful hotel room service trolley appears from the floor. On it is a silver cloche, a coffee cup and a carafe of water. CAN takes each item and places it on the prison table. A glass of bucks fizz appears from out of his copy of War and Peace which is on the table, the coffee cup fills with freshly brewed coffee, and the cloche yields a stale piece of bread. CAN replaces the cloche and opens it again to reveal a plate of delicious pastries, cakes and croissants.

There's still something missing.
Of course! Music!
I pull the T.V. set as close to the yard window
as I can, find the music channel and turn the
volume all the way up.
The empty yard amplifies the music.
The whole prison reverberates with the
sound.
I take a break from brunch and dance to
Adele's **Hello.**

CAN'S wife appears here. He creates a rose out of his red napkin and gives it to her. They dance. She leaves. He is devastated.

ACTOR 1: Pacing.

CAN: Gunshots rouse me from a peaceful siesta.

 The T.V. screen is awash with blood.

ENSEMBLE: *A prominent lawyer and civil rights activist has been shot dead today. He was shot once in the head by an unidentified gunman whilst making a statement to the press, calling for an end to the violence between the government and minority activist groups.*

CAN: In his final tweet, he'd written about Gul and me:

 Their arrest is the greatest blow yet to freedom of press and expression. Without any social resistance, we'll soon find ourselves beyond the point of no return.

 I fling myself out into the concrete garden.
 I start pacing. Just as friends had advised, in an oval formation in the rectangular yard.
 Coming up against the same wall at each corner, I pace in the cold.
 One-two-three-four-turn.
 One-two-three-four-five-six-seven-eight-turn.
 One-two-three-four-turn.
 One-two-three-four-five-six-seven-eight-turn.

ACTOR 1: My son.

CAN: The hatch opens.

ENSEMBLE: 'Letter for you.'

CAN: It is placed into my palm like a white dove
 bearing glad tidings.

 The writing on the envelope is a familiar
 scrawl.

 I take it and go upstairs. Stretch out on a bed.

SON: *Dear Dad,*
 I thought I'd write a letter, but did wonder if
 my terrible handwriting might push you over
 the edge in the middle of all your troubles.
 Not to mention the spelling mistakes! Please
 forgive me.

 What a strange world this is. Someone has
 drawn walls and wires between us.
 I can't hide how much I miss you... 'Don't
 worry,' I tell myself, he'll turn up in the fresh
 light of some morning, maybe in the winter,
 maybe in the spring, maybe in the middle
 of his favourite season. We'll eat Nutella
 from the jar again, watch a match, maybe
 even take a road trip up Highway 61 in an
 old Cadillac, BB King belting out 'Thrill is
 gone!' as we race off into the sunset, like two
 cowboys.

 Don't worry... I know you won't, but never
 lose hope. The future is on our side. The
 greatest privilege of my life has been knowing
 your hands were holding the back of my bike
 in every adventure I set off on. Neither walls
 nor death can separate us. You're with me
 every day.

Read and write. Keep taking the piss out of everything and defy the days they've laid out in front of you.
Dad, I am proud to be your son and honoured to be your friend. I can't wait for the day when we'll meet again.
I kiss your hands and eyes.
Your son.

CAN: A very dear friend once gave me some advice:

ENSEMBLE: 'Don't be ashamed to bend if you're punched. If you insist on standing straight, your internal organs might be damaged. Best to just buckle under the pain and straighten up later.'

CAN: I take that advice today. I let go of the lump I'd been harbouring in my throat for months, and I buckle. I sob and sob for the first time in an unscheduled resistance break.

ACTOR 1: Agent.

CAN: Nothing smells here.
The campus is so thoroughly surrounded by
concrete, iron, wall and mortar that not even
odours can penetrate.
No comforting aromas of food, or soil,
flowers, or sweat or perfume. Only sewage.

It was in one of the early weeks when a letter
breached this blockade and a scent rose up
off the paper like incense.

WIFE: *I thought this scent would suit you: Agent
Provocateur.*

CAN: Only too true. Outside, the pro-government
press campaign is intensifying against me.
This week they brand me as an "enemy
agent" and a "traitor".

I drink in the scent and smile.

We become aware of ACTOR 1, moving through the audience.

ACTOR 1: Vigil.

CAN: One of our most respected colleagues, a
 veteran journalist, arrives at the prison
 gate at 8.30 on the cold morning of the 2
 December, carrying a wooden chair. He
 places it on the ground, sits down and
 announces the beginning of the Vigil of
 Hope.

ENSEMBLE: 'I'll stay here for a day. If every colleague
 keeps this vigil for one day, this will turn into
 a chain. Today I'm the first link in this chain.'

CAN: His one-man protest finds support straight
 away. The Press Council are inundated
 with offers of support from journalists and
 organise them into a rota. Coach loads
 come from all across the country to join the
 protest at the prison gate. Old folk songs drift
 over the walls, they hold kite festivals and
 concerts. In the coldest days of winter, come
 wind, rain or snow, the wooden chair draws
 crowds to the prison gate, we receive their
 messages, hear their voices and we feel less
 alone.

 On 12 December, our news coordinator
 at the paper has an inspirational idea. He
 brings our weekly editorial staff meeting to
 the prison gate. My colleagues discuss the
 agenda wrapped up in their coats in the cold
 winter's air. Then he visits me and asks for
 the headline.

 It's a symbolic act and it captures the
 imagination of the worldwide press.

ACTOR 1: Colour.

CAN: Prison has quite a long list of bans.
Rugs, curtains and heaters are forbidden.
Wearing a tracksuit to a legal visit is
forbidden, as are hanging anything on the
walls, placing a lamp on the table, or using a
typewriter.
Soil or potted plants in the cell are forbidden.
Reading a book during transport or chatting
with the other prisoners is forbidden.
One of the things I miss most is colour.
Interior walls are dirty yellow, iron doors are
brown, floor tiles are beige and the kitchen
worktop is metal.
The plastic table and chair are white. As is
the light of the fluorescent strip.
There is no other colour. Even coloured pens
are forbidden.
But where people live, there will be colour.
I put my address at the bottom of the
columns I smuggle out to the paper, and
add, 'Anyone who wants to write to me is
welcome.'
The moment friends and family hear about
the colour ban, they post colourful envelopes
and sheets and pads of paper.
One friend sends in a couple of fleeces, one
turquoise and the other orange.

The stage is flooded with colour.

A reader sends in nature photographs; I festoon
the grey worktop with grass, flowers and trees.
The more you are restricted, the more
determined you become to break free.
I learn how to make colour.
I stick coloured newsprint onto steamed glass
and scrape off the dripping ink using a razor
blade.

71

First, I distill yellow ink from the coat of a
society bride and I paint a daisy.
Then I dip into the red jacket of a jet-set crown
prince to paint a rose.
I feel like a Robin Hood stealing colours from
the rich, for his humble abode.
Not satisfied, I attack the fruit next.
Dipping my toothbrush into orange scraped
from orange peel, burgundy from radishes and
green from apples, I paint *June Protest*.
That's how I overcome the colour ban.

ACTOR 1: New Year's Eve.

CAN: At the end of December snow sprinkles like
 confetti over the rooftops, dancing in the
 prison searchlights…
 I watch from the window: the snowflakes
 shove and push each other. When they land
 singly on the stones, they melt and vanish.

 But while we are sleeping, the snowflakes
 realise that when they stop scuffling with
 each other and unite, it snows hard enough
 to cover the yard.
 When I wake on 29 December, the snow is
 laid out like a spotless sheet.

 I pull on my coat and fling myself on top of
 the snow and make a snow angel.
 Enjoying the pure white.
 I write my favourite names in huge letters in
 the yard so passing aircraft can read them.
 I draw shapes with my footsteps and pummel
 the iron gate with snowballs. Just as I'm
 about to make a snowman, a parcel sails over
 the wall and lands in the yard.

A parcel flies in.

 It's from my neighbours.
 And in it, is a hot cheese toastie. I have no
 idea how they have made it.
 It is absolutely delicious.
 They are being tried today on charges of
 'inciting an uprising', because of a magazine
 cover they published.
 In the afternoon the news comes that they
 are to be released.
 As they leave, I hear their footsteps echoing
 away in the corridor.

The recipe for *Inmates Hot Toastie* appears in their newspaper next morning:

ENSEMBLE:

Quarter a loaf of bread. Remove the inside and replace with the cheese. Wrap it in a carrier bag, and put it between the bars of the radiator. Your hot toastie is ready in the morning.

CAN:

I smile. It is ingenious.
That night I make one for myself.
And I wake on the morning of New Year's Eve to a hot toastie cooked on the hearth that is my prison radiator. Waiting for me in its narrow slot, warmed through to the heart. If life is about finding happiness in small things, prison is a masterclass.

It's deathly quiet today. But I'm determined to be cheerful.

The paper has announced that a New Year's party will be held at the prison gate that afternoon and that my wife and son will be there. I'm delighted by the thought that they'll be so close by. Maybe I'll hear them singing.

But the snowstorm outside turns into a blizzard. By the afternoon there are T.V. reports of a huge traffic accident involving more than thirty cars on the main route to the prison.
The lack of telephone or of any means of communication is unbearable.
There's no more news. Nothing on any of the channels. No one says anything.
Tomorrow, I will discover that they are safe and well.

But tonight, for the first time, I fear that I am now completely alone.

ACTOR 1: Gul.

CAN: At first, my colleague Gul and I are placed
 in adjacent cells and forbidden from any
 contact. Then from time to time, we are
 allowed to meet while we take exercise
 under the constant gaze of the wardens.

 Other inmates can hold five-a-side matches.
 But because of the charges against us, all we
 are allowed to do is to kick and catch a ball
 between the two of us.

 Gul plays brilliantly – like the classy athlete
 he is, but I take all my rage out on the ball.

GUL: Anyone would think you're kicking
 somebody's head in.

CAN: The harder I kick, the higher the ball goes; I
 always end up kicking the ball up to the roof
 or into the overhead wires.
 These two distinguished newspaper editors
 then have to wait for the guards to fetch their
 ball back, like two downhearted kids.

 Then, on 4 January, the warden comes in.

ENSEMBLE: 'I've got good news for you.'

CAN: Half an hour later Gul moves into my cell
 with all his belongings.

 To be honest we aren't all that close. We
 don't really know each other at all. And
 suddenly we're sharing every moment with
 each other. Gul seems to exist solely on
 books, newspapers and cigarettes. So many
 cigarettes. As soon as he arrives, he turns the
 nook under the stairs into a library.

But Gul proves a true comrade. He is a
journalist who's been living and breathing
politics for years.

GUL: We discuss the progress of our legal appeal
against our pre-trial detention – as it is
rejected by each and every one of the courts
across the land.

CAN: We have impassioned political debates, listen
to music, sing songs when we get tired, and
watch football together at the weekends.

GUL: But we have one single T.V. set and a single
remote control.

CAN: At first we check to see what was being
discussed on the panel debates in Gul's
absence.
But I soon begin to try to distract him from it.
The moment any debate founders, I zap us
towards a film.
Sometimes even a reality T.V. show.

And he raises his head from his book,
glances quizzically at this bizarre world of
daytime television, and clicks his worry
beads even faster.

Three weeks after Gul moved in with
me, the charges against us brought by the
government are confirmed..

GUL: 'They're seeking two life sentences for you,
one aggravated. Plus a thirty-year sentence.'

CAN: 'That's fantastic!'

GUL looks unconvinced.

CAN: 'Come on – if they'd said two years, I'd
be worried, but multiple life sentences

is ridiculous! It's a farce. They've got no
evidence! We'll be out before you know it,'

Then on the 8 February our CEO brings
good news;

CEO: 'The Constitutional Court has announced it
will review your appeal. The review date is
set for 25 February.'

CAN: I am flying.
I start packing.

Gul isn't as thrilled as I am.

GUL: 'You don't know the pro-government media.
There's trouble brewing around the progress
of our case. Some plot will emerge to prevent
our case being heard.

If the Constitutional Court reject our appeal
we'll never get out.'

CAN: I know he is right. The higher your hopes
are, the harder the fall. But I think, what's the
point of flying if you only hover just above
the ground? Better to risk it and soar as high
as you can.

ACTOR 1: The Sun.

CAN: Is it true that what doesn't kill you makes
 you stronger?
 There is no horizon in the cell. Just like our
 steps, our gaze comes up against a wall no
 matter which way we turn. Which is why
 every evening, before the guards come to
 remove from our sight the fading sky, its blue
 face paling, we gaze at that rectangle of sky
 long and hard, taking our fill. I know spring
 will be the hardest part. Spring brings hope.

 As the snow recedes, we swing wildly
 between believing we'll be out any day now,
 and fearing we'll be in here forever.

 The days start to grow longer, warmer,
 and the cynical laughter of the crows is
 now accompanied by the first chirps of the
 canaries.
 The freshness of the buds popping outside
 floats in. The first touch of spring on the yard
 pierces my heart.
 Nature begins somersaulting in my blood.
 The sun is now my calendar.

 With each day it reaches further towards
 me. and I convince myself we will be out by
 the time it comes down the wall and fills the
 yard.

 By the end of January, it creeps down to
 nearly two metres above the iron door.
 By early February, I'm able to stand on the
 chair and touch it with my tired fingers. Like
 a father measuring his child's height, I mark
 its position on the wall.
 When I step onto the plastic chair on 13
 February, I feel sunlight on my face for the
 first time in months. It brushes over my

forehead and down to my chin.
As it starts to rise again ten minutes later, I
reach up on tiptoes to keep its touch on my
skin for a little longer…
After it's gone, I'm glowing as if I've
sunbathed for the first time in my life.

ACTOR 1: Spring.

CAN: The rain never stops all through the night.

It lashes the roof.

At 7am, on 25 February, I wake with irrepressible hope inside.

It is the day of the Constitutional Court decision on our appeal.

The sun rises and finally it engulfs the yard.

Spring has come.

ACTOR 1: Release.

GUL: 'Unlawful! They've declared our pre-trial
 detention, unlawful.'

CAN: We will be released before we go to trial.
 We hug.
 We hop and skip like children.
 Every channel runs the Constitutional Court
 verdict at the same time.
 The Warden comes in to congratulate us,
 adding the good news that we could be out
 of there within an hour of him receiving the
 order.
 The hours drag like weeks.
 We can see on T.V. our friends and family
 arriving outside the prison.
 Our solicitor arrives and explains the release
 procedure. He reminds me that our case
 is far from over and warns me not to say
 anything else that might get me into trouble
 on our way out.

 I reassure him.
 'We aren't after revenge; all we want is
 justice. For everyone.'
 I want to remind everyone about all the
 journalists still inside and I want thank our
 vigil keepers.
 They have shown that a wooden chair can
 overturn the will of a gilded throne.
 At 2am the guards finally arrive; we load our
 stuff into a handcart. We call up the corridor to
 our neighbours:

CAN & GUL : 'God save you,'

ENSEMBLE: 'Don't forget us,'

CAN: they call from their hatches.
 We board a white van.

And are welcomed into the arms of our friends,
families, and supporters, waiting at the prison
gate.

ACTOR 1: Trial.

CAN: The trial date is set for the 6 May.
 The government is coming under increasing
 international pressure to protect freedom of
 speech and as the case against us is being
 brought by the President himself, our fate
 is being talked about as a major test of
 democratic freedom.
 Finally, things are going our way. We begin
 to believe again that truth and reason will
 prevail.
 On the morning of our trial the sun is out
 and I walk hand in hand with my wife to
 make my statement to the press on the steps
 of the court house:
 'This is an attempt to arrest an entire
 profession, and with it, an entire nation.
 What we are seeing here is/'

ACTOR 1 reaches the stage, raises a gun and fires.

Gunshot.

Blackout.

ACTOR 1: Exile. Germany. 31 May 2018 *(Insert today's date.)*

A pavement café in Berlin. Birdsong. Sunshine, traffic noise. CAN sits reading a newspaper and enjoying brunch. He does not acknowledge the audience. Radio sound from within the café moves from traffic news/ headlines into Adele's 'Hello'. The song transports CAN from this peaceful moment back to his cell, reminding him of his separation from his wife and son, and of all the other journalists still in prison. The music is interrupted by sound interference. Out of the corner of his eye CAN spies, for the first time, the GUNMAN arriving in Berlin. At the moment of seeing each other:

White noise.

BLACKOUT.

Not The End.

DAY OF THE LIVING

CO-CREATOR AND WRITER JULIET GILKES ROMERO
CO-CREATOR AND MUSIC & LYRICS DARREN CLARK
CO-CREATOR AND DIRECTOR AMY DRAPER

Time

Past. Present. Future

Where

Mexico

Inspired by the fight for justice for the abducted Ayotzinapa teacher training students and the thousands of murdered and disappeared in Mexico.

Day of the Living was co-created as a result of a research and development in the UK and Mexico, and was informed by a devising process.

Verbatim material from *I Couldn't Even Imagine That They Would Kill Us: An Oral History of the Attacks Against the Students of Ayotzinapa*. Copyright © 2017 by John Gibler. Reprinted with the permission of the author and his publisher, City Lights Books.

Our special thanks to designer Charlie Cridlan.

We would also like to thank dramaturg Nic Wass, the creative team and company.

This text went to press prior to opening night and may differ from the play as performed.

Characters

MASKED CAST; GRANDFATHER; MANOLO

MOTHER; GRACIELA

DAUGHTER; CHAVELA

LUCHA LIBRE WRESTLERS

MOTHER EARTH- TLALTECUHTLI

AZTEC WARRIOR

DEATH

HALF-MASKED CAST; THE MEXICAN PRESIDENT, SHAMAN, POLICE, MILITARY, GOVERNMENT OFFICIALS, GODS, SEÑORA BLANCA.

UNMASKED; THE ENSEMBLE

ENSEMBLE; JAMIE CAMERON, ALVARO FLORES, JIMENA LARRAGUIVEL, EILON MORRIS, TANIA MATHURIN, ANNE-MARIE PIAZZA

Text
Unspoken mask dialogue is represented in bold italics.
Monologues are read by alternating members of the ENSEMBLE.

Glossary
Tlaltecuhtli – Mother Earth
Ayotzi – Ayotzinapa students
Paysano – Countryman
Campesino – Peasants
Compa – Short for campesino
Compañero – Colleague
Ofrenda – Ritual Altar
Lady of Guadalupe – The Virgin Mary
Pozolero – Stew Maker
Lucha Libre – Mexican Wrestling
Luchador – Wrestler
Narcos – Drug traffickers
El Venado – Stag
Costa Line – Bus Company
Estrella Roja – Bus Company

Pre-show Songs

SONG: STREET OF BONES

TANIA:
I'll meet you out in the heat
On the street of bones
We'll stumble over our feet
On the street of bones
Come dance the darkness
Down through the doorway
I'll have it mine,
And you have it your way
You can't compete with the beat
On the street of bones

TANIA/ANNE-MARIE:
You can hear the music start
On the street of bones
It's not for the faint of heart
On the street of bones
See Katrina, she's in a tangle
Look at death from a different angle
Once you start, you're part
Of the street of bones

WOMEN:
La calle de calaveras
La calle de calaveras
La calle de calaveras oh

ENSEMBLE:
You've been gone so long my love
Won't you stay with me
You've been gone so long my love
Won't you stay with me

TANIA/ANNE-MARIE:
Ain't nothing like the sound
On the street of bones
People pounding the ground
On the street of bones
No one is crying, no one is grieving
And no one looks even close to leaving

 Pure sound surrounding
 The street of bones

WOMEN: La calle de calaveras
 La calle de calaveras
 La calle de calaveras oh

ENSEMBLE: You've been gone so long my love
 Won't you stay with me
 You've been gone so long my love
 Won't you stay with me

TANIA & ENSEMBLE: I'll meet you out in the heat
 On the street of bones
 We'll stumble over our feet
 On the street of bones
 Come dance the darkness
 Down through the doorway
 I'll have it mine,
 And you have it your way
 You can't compete with the beat
 On the street of bones

 On the street of bones
 On the street of bones
 On the street of bones

SONG: YO SOY EL VENADO

ALVARO: The sound of the river
 The earth at my hoof
 Yo soy el venado
 The sky is my roof

 The wind of the mountains
 The sap of the tree
 Yo soy el venado
 Their song is in me

Yo soy el venado
The eagle has flown
Yo soy el venado
I stand on my own

I stand in the clearing
Alone in the shade
Yo soy el venado
And I am afraid

The cry of the arrow
As swift as a breath
Yo soy el venado
the sound of my death

Yo soy el venado
The eagle has flown
Yo soy el venado
I fall on my own

The hunter may kill me
My body may burn
Yo soy el venado
And I will return

In the cry of the eagle
In the Mexican sky
Yo soy el venado
My song cannot die

Yo soy el venado
Made of blood and of bone
Yo soy el venado
But I am not alone
Yo soy el venado

SONG: THE MARIGOLDS OF MEXICO

ENSEMBLE:

The ancient gods of Mexico
Are straying from their bed
The ancient gods of Mexico
The living folk of Mexico
Give flowers to their dead
The marigolds of Mexico

The church bell chimes
The still air moves
The dead are on their way

Dia de los Muertos
Dia de los Santos
Dia de los Muertos ah

Dia de los Muertos
Dia todos los Santos
Dia de los Muertos ah

The ancient heart of Mexico
Is bleeding through the earth
The ancient heart of Mexico
The flowers spring from Mexico,
The land that gave them birth
The Marigolds of Mexico

The incense burns
The candle glows
The gods are on their way

Dia de los Muertos
Dia de los Santos
Dia de los Muertos ah

Dia de los Muertos
Dia todos los Santos
Dia de los Muertos ah

A conch shell is sounded. The ENSEMBLE spreads out around the edges of the space.

A recording of student verbatim statements in Spanish follows.

Verbatim – The Mission

Spanish voices of surviving Ayotzinapa students bleed into English testimonials by the ENSEMBLE.

JORGE HERNÁNDEZ ESPINOSA, 20, FRESHMAN. … there is a teacher's college, a boarding college…it's called Ayotzinapa…

SANTIAGO FLORES, 24, FRESHMAN. …all the expenses are covered–the school covers everything–and for that reason, really, the economics, that's why I came.

MIGUEL ALCOCER, 20, FRESHMAN. I came…due to a lack of money…You know, it was the only option, economically, because here you don't pay anything for food or lodging…

JUAN PÉREZ, 25, FRESHMAN. The majority of students here are the sons of campesinos…I decided to come to this school, to study, to be someone, to go back to my town and be a teacher…

ANDRÉS HERNÁNDEZ, 21, FRESHMAN… I came here with that objective, to go back and give classes in my community…

JOSÉ ARMANDO, 20, FRESHMAN. …And this school is committed to social struggle; it's a school where we learn the values to keep fighting and create a better future, to support our families.

EDGAR ANDRÉS VARGAS, 20, JUNIOR. …On the first day…They talked to us about the college, about its creation… the social movements there have been in the country, and about the bad governments. Sometimes they showed us videos… related to, you could say, left politics.

SANTIAGO FLORES, 24, FRESHMAN …only those who make it through the trial week get admitted.

JORGE HERNÁNDEZ ESPINOSA, 20, FRESHMAN. … the trial week is hard…they make us do all the work of a campesino,

SANTIAGO FLORES, 24, FRESHMAN …farm work, clearing brush and weeds from the fields…

MIGUEL ALCOCER, 20, FRESHMAN. …feed the livestock, plant, feed the pigs and hens

JORGE HERNÁNDEZ ESPINOSA, 20, FRESHMAN. the work that a campesino does in a month, we do that in a week

MIGUEL ALCOCER, 20, FRESHMAN. …The truth is, for me it was easy because it was all the things I've done with my parents

EDGAR ANDRÉS VARGAS, 20, JUNIOR. They took us running.

SANTIAGO FLORES, 24, FRESHMAN … the organizers would encourage us. "Help each other out," they would say, "…never leave a compa alone, no one should ever get left behind".

ÓSCAR LÓPEZ HERNÁNDEZ, 18, FRESHMAN. …with what happened to us on the twenty-sixth, it all was…really fucking useful because out there you really needed it, you had no idea where to run, and here at the college they had taught us to run

Mother Earth

TLALTECUHTLI erupts from the ground. A creature and yet Goddess weighed down by clods of earth, stones, flowers flourishing, shrivelled and decomposing leaves. TLALTECUHTLI walks slowly, with purpose, across the space.

ENSEMBLE: They say the creator Gods enticed
Tlaltecuhtli from her domain in the ocean
and then tore her apart. And then it is said
that all the trees, the flowers and grass,
needed by human creatures, grew from
her broken back. Her nose became the
mountains, her eyes became the lakes and
the rivers, her skin forged the valleys and
caves and her hair became the forests. And
so, Tlaltecuhtli was reborn, nurtured by the
Mexican Sun, and soothed by the songs and
prayers of humans giving thanks for the earth
and all that she offered.

A Short History of Mexico

A small town in Guerrero state. MANOLO FERNÁNDEZ arrives in the plaza. He stops in his tracks when he sees a Mariachi band. In his youth, MANOLO used to play percussion regularly. And so, delighted by the music, he approaches the players.

Across the town square is his granddaughter, CHAVELA. She's carrying an armful of windmills she's hoping to sell. CHAVELA sees her grandfather, MANOLO, who has joined in with the musicians. She runs up, hugs him and gives him one of her windmills. CHAVELA crosses the square to find a spot where she can sell her wares. She lays them out for the public to see.

SONG: A SHORT HISTORY OF MEXICO

ALVARO: This will be a brief history of Mexico
We'll keep it short, a verse…

ANNE-MARIE: …or forty

ALVARO:	...on Mexico The Toltec Teotihuacan The Maya of the Yucatan The Aztec town Tenochtitlan in Mexico
ALVARO/ ANNE-MARIE:	Let us ride the rolling tide of history There's always more behind the door of history
ALVARO:	Aztec football played for fun Lots of fun for those who won
ANNE-MARIE:	Loser sacrificed to sun
ALVARO/ ANNE-MARIE:	In Mexico
ALVARO/ ANNE-MARIE:	Religious murder was so rife Extracting organs with a knife A bit of death was part of life And there's so much more to go
ENSEMBLE:	Una breve historia de Mexico Una breve historia de Mexico
ALVARO:	To understand this ancient land Of death and limes We must return and try to learn From ancient times
WOMEN:	They fought each other, grew their grain They asked the gods for peace and rain
ALVARO:	Instead of peace, the gods sent Spain... To Mexico
ALVARO:	The record says, Hernan Cortez, Conquistador Took a cruise to Veracruz's Pretty shore

WOMEN: Moctezuma gave him gifts
He'd never seen before

ALVARO/JAMIE: The Spaniard thanked him for his gifts
With death and war

ENSEMBLE: Toltec treasures to behold
Shining cities, wealth untold

ALVARO: The Spanish King was shitting gold

ENSEMBLE: And there's so much more to know

Una breve historia de Mexico
Una breve historia de Mexico

What we know is not the only way it was
The truth is not necessarily what they say it was
Hidalgo rings the churches bell
Independence raising hell

ALVARO: We're up to 1824
The US knocks upon the door

JAMIE: We'll take Texas por favor

ENSEMBLE: And there's so much more to go

Quesadilla, tortilla,
Pancho Villa and Santa Anna
Emiliano Zapata,
Piñata and marijuana
Despacito, bandito,
Big burrito and Salma Hayek
Philanderer Rivera
and his house sharer Frida Kahlo
Mariachi, Sombrero,
Guerrero, La Cucaracha
And El Chapo, Drug Dealer,
The little worm in the tequila
La Bamba and Juarez and Diaz,
Carlos Santana

And Del Toro and Zorro
And the girls of Tijuana
and the Songs for the narcos,
Narco Corridos
And hundreds and thousands
Of desaparecidos
Una breve historia

Una breve historia de Mexico
Una breve historia de Mexico
Una breve historia
Una breve historia
Una breve Historia de Mexico

ALVARO: Una breve historia de Mexico
Una breve historia de Mexico

Walking Wounded

The Fernández home. GRACIELA arrives. She's carrying a large piñata.

ENSEMBLE: This is Graciela Fernández. She smells of
church incense and warm Mexican sweet
bread which she bakes most days.

*GRACIELA stands on top of a stool helped by her father MANOLO who's
just entered. GRACIELA attaches the piñata to a hook in the ceiling.*

ENSEMBLE: Life's been hard without a husband but
Graciela knows how to fake material comfort
with pretty colours and crepe paper. That's
why she's busy with her daughter's birthday
piñata and this year has made it herself.

MANOLO sits with some wrapping paper and a pair of scissors.

ENSEMBLE: Manolo is Graciela's father. He lives off
the land, surrounded by the hills and silk

cotton trees of Guerrero, as his family has always done. *(a beat)* Manolo loves music and dancing but right now, he's worried the paper for his granddaughter's birthday present, is looking rather cheap. He's also a little bothered by the feathered Aztec warrior eyeing him from the living room corner, *(MANOLO looks across at the Aztec)* the same warrior who appeared the day his grandson Rafael disappeared, the same warrior who stalks him at the lime farm where he's worked all his life. It's dangerous employment. Narcos have come, demanding a share of the profits in exchange for protection from rival men with guns. So now, Manolo is forced to hustle as a shoe shine in order to help find the extra money for Chavela's special gift.

GRACIELA fusses with the piñata, making sure it swings from the hook.

ENSEMBLE: Graciela has raised her two children through God's good grace to be thankful for the smallest pleasures in life. Her son Rafael whom Chavela has nick-named El Venado, on account of his loveable size, is normally the one who hangs the piñatas. Chavela is ten today but since all the violence friends are in short supply so Graciela wants to make sure she has fun.

CHAVELA arrives. GRACIELA affectionately tidies her daughter's hair and clothes.

She turns CHAVELA to face her grandfather then places her hands over CHAVELA'S eyes, although CHAVELA keeps trying to peek through them.

MANOLO retrieves the present he's just wrapped and puts it carefully in CHAVELA'S hands.

Excited, she rips it open, discarding the paper.

CHAVELA.	*(Elated.) It's a camera!*
MANOLO.	*We remembered.*
GRACIELA.	*Felicidades niña!*
CHAVELA.	*Thank you!*

CHAVELA hugs and kisses her mother and grandfather. GRACIELA and MANOLO pose for a picture. CHAVELA takes several. Finally, GRACIELA hands CHAVELA a stick for the birthday piñata.

GRACIELA takes pictures as CHAVELA spins around trying to break open the piñata. MANOLO and GRACIELA dodge out of her way, laughing and clapping.

The ENSEMBLE approach and sing a Spanish happy birthday song.

Finally, CHAVELA makes contact. The piñata bursts open.

A plastic bag containing a severed head falls with a thud to the floor, accompanied by the sound of gunfire.

Verbatim – A Call To Action

CARLOS MARTÍNEZ, 21, SOPHOMORE. Every year people commemorate the October 2 massacre in Mexico City…

ALEX ROJAS, FRESHMAN. …the (1968*) massacre of students at Tlatelolco…

CARLOS MARTÍNEZ, 21, SOPHOMORE. A part of the commitment that we make to attend the march is to gather enough buses to get to the march…

JOSÉ ARMANDO, 20, FRESHMAN. …because Ayotzinapa was to host other students who would all travel together

URIEL ALONSO SOLÍS, 19, SOPHOMORE. On September 26, I remember, we sophomores had gone to observe

elementary schools...I came back to school...at around three in the afternoon.

MIGUEL ALCOCER, 20, FRESHMAN. That day...we had classes...Here at the school there are five areas: farm work, academics, marching band, the rondalla... and dance.

ALEX ROJAS, FRESHMAN ..we were at dance club practise when they told us...

JOSÉ ARMANDO, 20, FRESHMAN We...were working in the fields, planting corn and cempasúchil and tapayola flowers. At five o'clock they called us to go out on an action

ERICK SANTIAGO LÓPEZ, 22, SOPHOMORE ...to get some buses, nothing else...

JOSÉ ARMANDO, 20, FRESHMAN We all gathered together and we went in two buses that we already had at the school

URIEL ALONSO SOLÍS, 19, SOPHOMORE We left for Iguala...

JOSÉ LUIS GARCÍA, 20, FRESHMAN. ...around five or five-thirty in the afternoon...

URIEL ALONSO SOLÍS, 19, SOPHOMORE around six.

ALEX ROJAS, FRESHMAN around six

MIGUEL ALCOCER, 20, FRESHMAN around six

JOSÉ ARMANDO, 20, FRESHMAN ...at six.

URIEL ALONSO SOLÍS, 19, SOPHOMORE During the drive everything was really fun.

ALEX ROJAS, FRESHMAN. I was in the second bus. We were all talking and having a good time.

GERMÁN, 19, FRESHMAN ...messing around like always, you see how we are, talking, fucking around, talking about girls...

ALEX ROJAS, FRESHMAN. My compañero, the one who was sitting next to me, is named Miguel Ángel Mendoza. He is disappeared.

URIEL ALONSO SOLÍS, 19, SOPHOMORE The compa in charge of organizing that action, a sophomore, is disappeared. His name is Bernardo Flores, but we call him Cochiloco, Crazy Pig...

IVÁN CISNEROS, 19, SOPHOMORE.... The atmosphere, I tell you, was fucking awesome.

A Severed Head

CHAVELA is in the plaza playing with her brand-new camera. She's taking pictures of people and things. Suddenly CHAVELA sees a strange-looking bag lying on the ground. She takes a closer look then recoils. CHAVELA swivels around to make sure no one is looking, then takes a quick picture.

ENSEMBLE:	There seems to be a severed head... sitting inside a bag by the sidewalk... baking in the midday sun. It's not normal... but not, not normal. Chavela has been taught to look away from or un-see such things, especially since all the trouble with Rafael.
	And for good measure, her mother always adds that if she insists on looking, El Chupacabra will crawl out of the sewer and eat her whole. But Chavela is not afraid of a stupid tale told to frighten children.
POLICEMAN:	Hey? You?

A local POLICEMAN approaches. A gun hangs from his waist.

POLICEMAN:	Are you OK? Are you playing?

He looks at the dead head.

POLICEMAN: I'm sorry you have to see something like this.

The POLICEMAN draws closer.

POLICEMAN: That's a nice camera. Let me see it.

CHAVELA hides the camera behind her back.

POLICEMAN: You shouldn't be taking pictures of this. I suppose you want to be a journalist. That's a dangerous profession. Can I see your camera?

CHAVELA backs away.

POLICEMAN: Come on. Show me.

The POLICEMAN catches CHAVELA by the arm and snatches the birthday present. CHAVELA tries to take back the camera. The POLICEMAN dangles it in front of her.

POLICEMAN: *(Teasing)* Niña.

He holds the camera above his head as CHAVELA jumps to reach it.

POLICEMAN: Calm down. Stop it.

CHAVELA continues to jump.

POLICEMAN: *(Suddenly serious)* Stop.

The POLICEMAN offers CHAVELA the camera.

She tries to take it but the POLICEMAN holds onto the camera's strap.

He finally lets go.

CHAVELA takes her camera and inspects it for damage.

The POLICEMAN points his gun at her. For a moment it looks as if he's about to shoot her.

He motions for CHAVELA to scram.

She runs.

SONG: NOT NOT NORMAL

TANIA:

There's a severed head
A'sitting on the sidewalk
Baking in the midday sun
That's not normal

JIMENA/ALVARO:

But it's not not normal

TANIA:

He's got a fist full of fingers
sticking out of his mouth
As a warning out to everyone
That's not normal

TANIA / JIMENA:

But it's not not normal

MANOLO enters, wearing a suit. He brushes specks of lint from the shoulders and pulls the jacket straight then sits in an armchair and begins to vigorously shine his shoes

WOMEN:

And the cartels kill at a quarter to six
to get the killing on the evening news
and mutilated bodies make front page pics
And the bodies are dissolved in stews

ENSEMBLE:

But the sun is shining, the mood is bright
And there's singing and dancing every night
And that just don't seem right

That's not nah nah nah nah nah nah nah
that's not normal
But it's not nah nah nah nah nah nah nah it's
not not normal

ENSEMBLE:

Manolo has retrieved the best suit he
owns. His feathered Aztec warrior friend
is worried. Manolo is planning to take part
in a demonstration for his missing grandson
and the other Ayotzinapa boys. It could be
dangerous. But state officials will likely be
there and Manolo wants answers. There are
rumours that one of the buses taken by the

boys was carrying a concealed shipment of drugs belonging to assassins from a local narco gang. And why, wonders Manolo, has the President not bothered to come in person to meet the families of the Disappeared?

GRACIELA arrives, arms full with keep sakes, candles, a red tracksuit top, flowers and a large crucifix. She arranges them with care around the overflowing ofrenda.

ENSEMBLE: Graciela feels lost. Her father has begun to ramble with creatures and spirits that simply are not there. So she's going on pilgrimage to the Basilica of the Lady of Guadalupe. She intends to pay penance and beg for divine mercy. She knows the Lord alone has the power to end all the madness and bring her son back. Rafael is an innocent. He's just eighteen years old.

Finally, she takes the red tracksuit top. She holds it close, inhaling her son's essence, then places it reverentially on the ofrenda.

She crosses herself again, then kneels to pray.

JIMENA: Yet another mass grave, discovered in Guerrero
A'littering the mountain top
That's not normal

ENSEMBLE: But it's not not normal

CHAVELA rushes in frightened by her experience with the POLICEMAN. She tries to tell MANOLO what happened, she tries to show him how her camera's film was taken but MANOLO is too busy worrying about the protest rally. GRACIELA is trying to pray and has no time for her daughter either.

Dejected, CHAVELA discards her birthday gift and goes to play alone with her favourote Lucha Libre Dolls.

JAMIE: The police and politicians are raking in the money
with a cut from the cartel's crop

That's not normal

ENSEMBLE: But it's not not normal

DEATH swaggers into the living room with a flourish and dances with considerable style.

WOMEN: And forty-three students disappear from
some buses
on a hot September night
And a faceless boy is revealed on the road
At the dawn in the morning light

ENSEMBLE: But the people smile, the people hope
The gods only know how the people cope
Because Oh oh
Death finally exits.

That's not nah nah nah nah nah nah nah
that's not normal
But it's not nah nah nah nah nah nah nah it's
not not normal
That's not nah nah nah nah nah nah nah that's
not normal
But it's not nah nah nah nah nah nah nah it's
not not normal

Finally, MANOLO exits on his way to the protest rally. GRACIELA leaves to prepare for her pilgrimage. DEATH takes the head in the shopping bag and follows GRACIELA out of the house.

Verbatim – We Need Buses

ALEX ROJAS, FRESHMAN. The two buses stopped near Huitzuco…There's a little chapel there where a number of us who are believers went to pray and make the sign of the cross.

ÓSCAR LÓPEZ HERNÁNDEZ, 18, FRESHMAN. …we started to keep a look out for buses.

ALEX ROJAS, FRESHMAN …and sure enough, a bus passed by, which we stopped and commandeered….

URIEL ALONSO SOLÍS, 19, SOPHOMORE…We spoke with the driver and he said yes.

EDGAR YAIR, 18, FRESHMAN. …But he had passengers. So the driver needed to drop off his passengers at their destination, which was the bus station in Iguala.

ALEX ROJAS, FRESHMAN I was talking with some of the passengers… They said to me that they were afraid…. I told them not to worry, that we never did anything to citizens…. that we only did this action because it was necessary since we don't have any vehicles at the school to use for transportation…

IVÁN CISNEROS, 19, SOPHOMORE. We got to the bus station.

ALEX ROJAS, FRESHMAN all the passengers got off…but the driver said no

URIEL ALONSO SOLÍS, 19, SOPHMORE he had changed his mind

ALEX ROJAS, FRESHMAN the… security guards were on their radios

SANTIAGO FLORES, 24, FRESHMAN …there were some police cars patrolling…

IVÁN CISNEROS, 19, SOPHOMORE. We needed…. buses quickly…

COYUCO BARRIENTOS, 21, FRESHMAN. …We grabbed three in total.

IVÁN CISNEROS, 19, SOPHOMORE two Costa Line and an Estrella Roja.

COYUCO BARRIENTOS, 21, FRESHMAN And we had two other buses… There were five.

JUAN PEREZ, 25, FRESHMAN We left the station and we realised there were police trucks following us

SANTIAGO FLORES, 24, FRESHMAN. ….I was in a window seat and I saw people having dinner…. We went a few meters farther and…. I heard something like firecrackers. I thought they were fireworks…

CARLOS MARTÍNEZ, 21, SOPHOMORE. …We started to hear gunshots—a lot of gunshots.

MIGUEL ALCOCER, 20, FRESHMAN. The police started shooting.

EDGAR YAIR, 18, FRESHMAN. …We weren't scared because never. . . . Well, we knew that they couldn't shoot at us because we're students

GERMÁN, 19, FRESHMAN. we shouted out to them to leave us alone, that we were on our way out of town. We kept driving…and there were gunshots and gunshots…

EDGAR YAIR, 18, FRESHMAN. …the cops didn't even care that there were so many other people around, kids, women…

IVÁN CISNEROS, 19, SOPHOMORE. We said: "We're students, we're unarmed," but the police didn't give a shit…

Ayotzi Luchador

Left alone, CHAVELA continues to entertain herself with Lucha dolls. She makes them fight, re-enacting the matches she sees on TV.

A wrestling RING ANNOUNCER suddenly erupts into the room.

RING ANNOUNCER· Respetable público! Lucharán de cinco a seis caidas sin límite de tiempo!

CHAVELA jumps back and drops her dolls, astonished. The ANNOUNCER bellows into a microphone…

RING ANNOUNCER: And now Ladies and Gentlemen! Live from the Arena Coliseo. Let's get ready to RUMBLE!

CHAVELA can scarcely believe her eyes. She claps her hands with excitement. The RING ANNOUNCER strides around, dramatically whipping up an eager crowd.

RING ANNOUNCER: Six rounds for the undisputed Lucha Libre title of the WORLD!

Introducing first, fighting out of the red corner for the Ayotzinapa Normal school

It's the undefeated Normalista, Rafael the Stag 'El Venado'!

RAFAEL somersaults into the living room. Stunned, CHAVELA is up on her feet, hopping up and down, screaming with glee. The crowd also goes wild.

CROWD: El Venado! El Venado! El Venado!

RING ANNOUNCER: And Ladies and Gentleman in the blue corner, representing the Mexican world gone mad … the devil worse than your mother-in-law… run, hide… it's the federal investigator, Tomas Zerón de Lucio, fighting as the Grand INQUISITORRRRR!

The INQUISITOR leaps into the ring amid much booing, hissing and foot stamping.

He swaggers around, smugly loving the abuse. He flexes his biceps, kissing each.

CHAVELA: ***(Screaming) Rafael! Kill him. Mate-lo!***

RING ANNOUNCER: Luchadores, keep it clean.

RAFAEL goes to shake hands with the INQUISITOR who slaps his face.

111

The fight begins.

The wrestlers stalk each other around the ring. Punches are thrown. Bodies are slammed. RAFAEL manages to extricate himself from a painful Bear Hug. He gets the better of his nemesis then finishes him off with an excruciating Camel Clutch. The INQUISITOR begs for mercy. RAFAEL celebrates proudly, posing in the ring. CHAVELA is ecstatic.

CHAVELA/CROWD: **El Venado! El Venado! EL VENADO!**

Humiliated, the INQUISITOR crawls back to his corner and tags in another wrestler.

RING ANNOUNCER: But what's this? Ladies and Gentlemen, the contest is not yet over,

Defending officialdom and never ending corruption... save yourselves! Making his way into the ring... It's the Attorney General, Jesus Murillo Karam aka THE **PUNISHERRRRRRR!**

The PUNISHER leaps into the arena and laughs in RAFAEL's face.

PUNISHER: Pendejo!

Insulted, RAFAEL gets angry and launches himself at his new opponent. But the PUNISHER is faster and more devious than the INQUISITOR.

He grabs RAFAEL in a headlock. RAFAEL grabs his opponent's neck. The two stagger around the ring refusing to let each go.

RING ANNOUNCER: The battle is ON! Oh, it's getting ugly. Ladies and Gentleman, can El Venado fight to better his world, can this Normalista save himself!

RAFAEL finally manages to break free. He throws his opponent who lands painfully on his back. RAFAEL launches himself atop his foe and crunches him into a reverse Chin Lock. The PUNISHER bawls for mercy. RAFAEL finally lets him go.

CHAVELA/CROWD: EL VENADO! EL VENADO! EL VENADO! EL VENADO!

RAFAEL celebrates. CHAVELA jumps onto his back. RAFAEL parades around the ring with CHAVELA punching the air for joy. The RING ANNOUNCER interrupts the merriment.

RING ANNOUNCER: And now for the main event.

RAFAEL looks around surprised.

RING ANNOUCER: The one you've all been been waiting for… it promises to be a classic, folks! It's that Jezebel known as Sin. The Nose Candy of your nightmares… She's the undisputed conqueror of politicians and police alike. Weighing in at twenty-nine billion dollars, her fight record includes some two hundred thousand Mexican dead, that's more than in Iraq and Afghanistan combined! Ladies and Gentlemen, avert your eyes! It's Señora BLANCAAAAAAAA!

RAFAEL: *(Shock)* Puta madre.

CHAVELA slides off RAFAEL's back in fear. RAFAEL pushes his little sister out of the arena, ready to face SEÑORA BLANCA, the Goddess of Cocaine.

SEÑORA BLANCA makes her way like a predator into the arena.

Her jewelled Lucha Libre mask gleams, encrusted with diamonds and other precious stones.

Her obsidian eyes flash with lust and power.

Her white cloak is weighed down by nuggets of gold, dollars, sterling in every denomination and glistening bling.

Plumes of cocaine fumes swirl off her body as she leisurely enters the ring.

SEÑORA BLANCA throws off her cloak and faces RAFAEL.

RING ANNOUNCER: Luchadores. We want a clean fight.

A bout bell rings. SEÑORA BLANCA begins a formidable dance. She circles RAFAEL, then moves in for the kill.

SONG: LA SEÑORA BLANCA

ANNE-MARIE:
From deep in the heart of old Peru
Where the jungle drips with drops of dew
In the heavy heat of the forest night
She moves to the floor in flowing white

The rhythm grows, she starts to sway
Her heavenly hips have the right of way
The night gets deeper, the music louder
The touch of her hand is as soft as powder

Everybody follow the coca (x 2)

Come dance with the white lady
Come have a little taste you'll see
You can have a little fun tax-free
That ain't no lie I I

RAFAEL fights for his life but with super strength, the narcotic creation simply throws him about like a doll. She spins and grabs RAFAEL in a headlock.

Life ain't no paradise
But she can make you feel real nice
And she's available at market price
No V.A.T

Baila con la Señora Blanca
Baila con la Señora Blanca

SEÑORA BLANCA then body slams RAFAEL to the canvass and crunches him into a cruel and crippling Hammer Lock. The REFEREE gives RAFAEL a five second count. He then takes the microphone and sings….

JAMIE:
The coca queen is in another class
She'll get you high then she'll kick your ass
Won't be long before your pinned
You know that the winner is predetermined?

CHAVELA jumps back into the ring in a desperate attempt to save her big brother.

SEÑORA BLANCA grips CHAVELA and throws her to the floor.

> Everybody follow me so far?
> Good everybody follow the coca
>
> Oh what a twist it's the state police
> All the politicians want a little piece
> Everybody's got their foot in the ring
> Now who wants to hear the coca sing

CHAVELA crawls over to RAFAEL and tries to shield him with her body.
The REFEREE gives the microphone to SEÑORA BLANCA....

SEÑORA BLANCA:
> From deep within the earth I rose
> With every step my power grows
> Join the dance and you will see
> The birth of this new deity
>
> Bow down to a brand-new god
> Complete with a sweet death squad
> And a temper like a lightning rod
> Come with me

SEÑORA BLANCA has won. She stands in the middle of the ring proud,
undefeated. The REFEREE raises her hands in victory.

ENSEMBLE:
> Bow down to a brand-new god
> Complete with a sweet death squad
> And a temper like a lightning rod
> Come with me
>
> Bow down to a brand-new god
> Complete with a sweet death squad
> And a temper like a lightning rod
> Come with me

The REFEREE transforms into the POLICEMAN seen earlier and drags
RAFAEL, kicking and struggling, away.

Cries, boos and cheers ring out.

Scorched Earth

MOTHER EARTH looks on as her child SEÑORA BLANCA departs the scene of her latest violent conquest.

ENSEMBLE: For Tlaltecuhtli, years have passed, generations have passed, one hundred generations have passed. The sun has survived and she continues to bear the weight of human life. But on quiet nights, distant coastal settlements can hear the faint sound of her weeping. Tlaltecuhtli fears her strength is fast failing, ravaged by the vengeance, the senseless violence and bitter blood feuds waged upon her scorched flesh and now the Coca to which she gave birth brings her and the creatures she nurtures so much more pain.

Verbatim – Cross Fire

JORGE, 20, FRESHMAN. They were shooting at us all down the street, they were chasing us up to this intersection, I don't know what it's called.

IVÁN CISNEROS, 19, SOPHOMORE. …Juan N. Álvarez and Periférico

CARLOS MARTÍNEZ, 21, SOPHOMORE. …We were so close to turning onto the Periférico

IVÁN CISNEROS, 19, SOPHOMORE. when police truck 002 came out of nowhere and cut us off

SANTIAGO FLORES, 24, FRESHMAN. …Other students told us to move the truck. I got off the bus, others got off the

bus too.. I don't know if it was from fear or desperation, but we couldn't move the truck.

ANDRÉS HERNÁNDEZ, 21, FRESHMAN. We were pushing the truck when a second squad truck…pulled up and the police shot at us, brutally…

CARLOS MARTÍNEZ, 21, SOPHOMORE I ducked like this

IVÁN CISNEROS, 19, SOPHOMORE That was when they hit Aldo…

CARLOS MARTÍNEZ, 21, SOPHOMORE …with a shot to the head and there was so much blood…too much blood, too much.

SANTIAGO FLORES, 24, FRESHMAN the compas were shouting… "You shot one of us!" But the police…kept shooting and shooting. …"Help us, he's still alive"… But the cops ignored them.

SANTIAGO FLORES, 24, FRESHMAN The shooting lasted a long time

EDGAR YAIR, 18, FRESHMAN. …We ran to a place between… two buses….we were maybe twenty-seven there, I think.

JOSÉ ARMANDO, 20, FRESHMAN. …Everyone was erasing all their contacts from their cell phones because we thought they were coming to take us–like they always do when they repress us–off to jail or the police station

COYUCO BARRIENTOS, 21, FRESHMAN. …Whenever the compañeros tried to video record the police, the cops would shine a flashlight at the compañeros' cell phones to make it impossible to see the cops' faces, to keep from being filmed.

ERNESTO GUERRERO, 23, FRESHMAN. …We had nowhere to go. They were shooting at us from the front and from behind.

EDGAR YAIR, 18, FRESHMAN. We screamed to the police that we were unarmed, that we had nothing to hurt them with. We screamed for them to stop shooting at us,

MIGUEL ALCOCER, 20, FRESHMAN. And the police shouted back that they didn't give a fuck…They said

ERICK SANTIAGO LÓPEZ, 22, SOPHOMORE "you are beyond fucked." … "If you are all such badasses, then let's see it now, fucking ayotzinapos."

MIGUEL ALCOCER, 20, FRESHMAN …"Throw out your weapons!" And we were like, what weapons…

IVAN CISNEROS, 19, SOPHOMORE …. We shouted out… You should act so tough with the narcos. We didn't know that they were also the narcos

EDGAR YAIR, 18, FRESHMAN. …if you leaned out just a bit, they shot at you….

ERICK SANTIAGO LÓPEZ, 22, SOPHOMORE in my right arm

JUAN PÉREZ, 25, FRESHMAN. … in my left knee.

EDGAR YAIR, 18, FRESHMAN And we were there for a long time, almost two hours. …We were all…really scared… seeing how our compañero was still lying out in the street, convulsing.

JOSÉ ARMANDO, 20, FRESHMAN. …another compañero started dying… he already had some kind of a lung illness…. he was having trouble breathing

CARLOS MARTÍNEZ, 21, SOPHOMORE We called 066 so they'd send ambulances.

ERNESTO GUERRERO, 23, FRESHMAN The operators came out with the ridiculous story that they didn't know where we were. "I don't know where that place is," they told us, "we went and didn't see you all, we couldn't find the address." That ambulance never arrived. Squad truck 302 arrived.

EDGAR YAIR, 18, FRESHMAN. ...And the police, instead of picking him up carefully because he was sick, grabbed him like a dog, dragged him, and threw him in the back of a squad truck and drove off with him.

CARLOS MARTÍNEZ, 21, SOPHOMORE The number 066 is a federal number. It's impossible for the federal government to say that they didn't know what was happening...

ERICK SANTIAGO LÓPEZ, 22, SOPHOMORE.... we saw police with different uniforms... Because in all the testimonies it just says that the municipal police participated. They never talked about the federal police and the state police

ERNESTO GUERRERO, 23, FRESHMAN ...The compañeros on the third bus...were surrounded. The police... started to make them get off the bus and lie facedown on the street....If you moved, they shot at you. If you spoke, they shot at you.... And then after shooting they'd take the time to pick up the shells.

ERICK SANTIAGO LÓPEZ, 22, SOPHOMORE Two civilians arrived and got out of their car. I don't know if they were the leaders. They weren't wearing masks. One of them had a pistol. They were giving orders and the others were obeying them.

URIEL ALONSO SOLÍS, 19, SOPHOMORE. ..."Alright guys," he said, "let's make a deal. You all are going to turn yourselves in. We're going to take the buses. We're going to pick up the bullet shells, and we'll act like nothing happened here."

EDGAR YAIR, 18, FRESMAN At last an ambulance arrived.

ERICK SANTIAGO LÓPEZ, 22, SOPHOMORE The cops grabbed me and put me in an ambulance.... And...my compañeros in the different squad trucks....If they hadn't shot me I would also be disappeared....Everyone who was riding in the bus where I was is now disappeared....All the blood that was in the bus. . . . All that blood is mine.

URIEL ALONSO SOLÍS, 19, SOPHOMORE And then...The cops left.

Survival

The Basilica of our Lady of Guadalupe. An illuminated, crucifix towers over the church plaza. GRACIELA *and* CHAVELA *arrive.* GRACIELA *gives* CHAVELA *some change and sends her to watch some musicians perform. She then gets down on her knees and slowly, painfully proceeds in an act of religious devotion. As she makes her way,* GRACIELA *prays, beseeching the Lady of Guadalupe to help bring back her son.* CHAVELA *hates to see her mother on her knees. She wants to go home. She sits with the musicians who try to entertain her.*

SONG: MIDDLE OF THE MOON

ENSEMBLE:	In the middle of the moon
	In the middle of the moon
	In the middle of the moon
	In the middle of the moon
TANIA:	An obsidian skinned local girl
	Appears on the hill
	She appears to a man beneath La Luna
	She says 'hey Juan Diego,
	Boy, I'm taking you to bed.'
	Though the catholic contingent might contest
	That that was what she said
	I guess we'll know the truth
	Now that old Juan Diego's dead
	And his heart is in the middle of the moon
	Perhaps she said the words too loud
	For she was burned into a shroud
	But her heart is in the middle of the moon

ENSEMBLE:
In the middle of the moon
In the middle of the moon
In the middle of the moon
In the middle of the moon

TANIA:
Juan Diego's crying,
He is sinking to his knees
And the local girl is singing out a tune
She say's 'Hey Juan Diego,
Boy, don't you feel blue.'
'You ain't the only one who's sinking son,
This city's sinking too.'
'We got time upon our side
My love, it's 1532.'
And our hearts are in the middle of the moon

In the reflection of the lake
I see the eagle and the snake
And our hearts are in the middle of the moon

In the middle of the moon
In the middle of the moon
In the middle of the moon
In the middle of the moon

TANIA:
A native lady's kneeling,
But she stands out in the crowd
She knows the day of judgment's coming soon
She says 'Oh Juan Diego,
Won't you listen to my prayer'
'My sweet Santa Maria,
I can feel you in the air'
'Wherever my boy may be,
May you also be there'
If his heart is in the middle of the moon

Wherever he may be
Won't you return my boy to me
For my heart is in the middle of the moon

ENSEMBLE:
In the middle of the moon

In the middle of the moon
in the middle of the moon
in the middle of the moon

GRACIELA makes it to the Basilica. She stares up at a towering crucifix before her. In pain, GRACIELA reaches into her pockets for money; it is all she has. She deposits it at the foot of the cross.

CHAVELA returns to her mother then gently she helps her up, brushing the dirt from her mother's knees. Together they bow their heads in prayer then exit.

Verbatim – Chain Reaction

URIEL ALONSO SOLÍS, 19, SOPHOMORE …People started to come up and ask us what had happened…

COYUCO BARRIENTOS, 21, FRESHMAN. but they started to walk all over the evidence. So we made a human chain to protect the area.

ERNESTO GUERRERO, 23, FRESHMAN. We put rocks and sticks around the bullet shells and other evidence so that no one would pick them up or step on them…

URIEL ALONSO SOLÍS, 19, SOPHOMORE Our compañeros from the school arrived as well as some local Iguala teachers to offer help.

COYUCO BARRIENTOS, 21, FRESHMAN Someone called the local media…

URIEL ALONSO SOLÍS, 19, SOPHOMORE We thought…if the press arrived we'd feel safer.

COYUCO BARRIENTOS, 21, FRESHMAN but some of the journalists said they didn't have permission to report on the story

DAY OF THE LIVING

ERNESTO GUERRERO, 23, FRESHMAN Not a single soldier came: nor the state police, nor state detectives, nor the army, nor the federal police, nor the marines.

COYUCO BARRIENTOS, 21, FRESHMAN a few local reporters managed to show up…

GERMÁN, 19, FRESHMAN. …I was talking to my girlfriend on the phone. I was telling her that it was all over….

COYUCO BARRIENTOS, 21, FRESHMAN…Some of the compañeros who came from the school…were looking at cell phone videos…giving a statement to the press

URIEL ALONSO SOLÍS, 19, SOPHOMORE…Around one in the morning a convoy of unmarked cars arrived…. Men dressed in black, wearing face masks, with bulletproof vests, but without any government insignias on their clothes…

COYUCO BARRIENTOS, 21, FRESHMAN They started shooting…

COYUCO BARRIENTOS, 21, FRESHMAN They were spraying us with machine gun fire.

ERNESTO GUERRERO, 23, FRESHMAN A rainstorm of bullets

JOSE ARMANDO, 20, FRESHMAN And we saw two compañeros get hit and fall

GERMÁN, 19, FRESHMAN I didn't turn around to look, but started running and running…

JUAN RAMÍREZ, 28, FRESHMAN I ran

JORGE HERNÁNDEZ ESPINOSA, 20, FRESHMAN. … I ran

ANDRÉS HERNÁNDEZ, 21, FRESHMAN. I ran and ran…

URIEL ALONSO SOLÍS, 19, SOPHOMORE. …Run or die.

JORGE HERNÁNDEZ ESPINOSA, 20, FRESHMAN. ...
Then my compañero, the one whose face they cut off, I
remember I saw him running and screamed: "No, wait! Let's
go inside this house!" He kept running...He kept running and
I didn't see him again....

Protest

Lights up on MANOLO *who is amongst parents of the disappeared
Ayotzinapa students, gathered for a protest rally. He wanders about
handing out leaflets to members of the audience.*

> ### MARIO CÉSAR GONZÁLEZ
> ### CONTRERAS, FATHER OF CÉSAR
> ### MANUEL GONZÁLEZ HERNÁNDEZ,
> ### 19, FRESHMAN, IN FRONT OF
> ### THE GOVERNOR'S OFFICE,
> ### CHILPANCINGO, 4 OCTOBER 2014.

RECORDING OF CONTRERAS: *(Spanish)* A million pesos are
what our sons' lives are worth? That's
what he spends on a drinking binge. That
fucking pig.... We have an incompetent as
governor.... We are exhausted..... We don't
know what to do.... And they send us that...
Supposedly Peña Nieto wanted to change
this country... Why isn't he here now?

The Mexican President, ENRIQUE PEÑA NIETO, *has arrived with an
entourage of henchmen and flatterers.*

PRESIDENT: PEÑA NIETO. HOLA! Compañeros!

ENSEMBLE: Why will he not speak to us!

PRESIDENT: But I am here. All the way from your capital
Mexico City. It took me seventeen months to

get here! It's a very LONG way. Your roads
are crap! Fix them!

RECORDING OF CONTRERAS: *(Spanish)* They are forty-three. They
are students.... Our only crime is being
poor and looking for a school where we can
support our children....

My son is César Manuel González
Hernández... I won't let my guard down
until I find my son and take him home. And
I mean walking.

PRESIDENT: It is your greatest pleasure to see me here
with you! Let me and my muchachos
entertain you in the key of democracy! A
song that is at the top of the Government
chart! It's the historical truth and you have to
listen to it! This is my instrument! *(indicates
his guitar)* It's nice eh? You want to touch it?
Kidding!

SONG: ESTA ES LA VIDA

PRESIDENT: On the night that it happened
The students had stolen some buses
Unlucky for them they had chosen
The wrong ones to take
It turns out that were was a
Shipment of drugs on the buses
So the students really fucked themselves

ENSEMBLE: Esta es la vida
Vete a la chingada
Esta es la vida
Mis amigos
that's life

PRESIDENT: The students were killed by cartels
And then incinerated

125

Their bodies were dumped at Cocula
High up in the hills
So the witnesses say that their statements
Were not what they stated
The witnesses can suck my dick

ENSEMBLE: Esta es la vida
Vete a la chingada
Esta es la vida
Mis amigos
that's life

PRESIDENT: The scientists came and examined
The grave at Cocula
They said that our theory
Was all just a pile of lies
But I did not get to the top
By being a fool-a
Science can go and lick my ass

ENSEMBLE: Esta es la vida
Vete a la chingada
Esta es la vida
Mis amigos
That's life

PRESIDENT: The United Nations are sitting
Up there in their palace
The United Nations proclaiming
That we are corrupt
So I'm sending the United Nations
A Mexican phallus
So the U.N can go and fuck itself

PRESIDENT: *(Excited)* Now for my solo!

He takes a trumpet and gets ready to play.

MANOLO who's still handing out protest leaflets, gets in the way. He's manhandled by the PRESIDENT's henchmen who try to get rid of him.

PRESIDENT: *(Annoyed)* Who the hell is this! He's fucking
 up my song!

An aid whispers in the PRESIDENT's ear.

PRESIDENT: *(At henchmen)* Ah! What's wrong with you!
 My people are trying to get close to me. Let
 the poor man approach! Ven pa'ca!

He pulls MANOLO close for a hug and a long and vigorous handshake.

PRESIDENT: You are a grand-father! I am so sorry for
 your loss. We did all we could. Because
 in this great place... this... in Iguala! The
 cradle of our nation's independence! In this
 wonderful place your grandson is dead,
 gone, no more, kaput, finito! Were you not
 listening to the song? But we will help
 your people *(he forces money into MANOLO's
 hand)* with food and FIESTA!

MANOLO looks at the money then throws it to the floor with contempt.

PRESIDENT: Ya me cansé! Chingados!

*The PRESIDENT snaps his fingers and his henchman unceremoniously
eject MANOLO.*

The PRESIDENT takes his trumpet once more.

PRESIDENT: Un. Dos. Tres!

He blows the instrument loud and discordantly.

ENSEMBLE: Esta es la vida
 Vete a la chingada
 Esta es la vida
 Mis amigos
 that's life

ALVARO: I'll admit that the country
 is stuck in a bad situation
 If you will admit that
 there's little that one man can do

Everyone knows that the narcos
Have purchased the nation
Well the narcos can go and…
Just keep doing what they're doing
Because they're doing
A pretty good job.

Esta es la vida
Vete a la chingada
Esta es la vida
Mis amigos
That's life

Courage

GRACIELA is in the plaza, struggling home with food shopping. She is exhausted and worn down by grief.

The POLICEMAN who stalked CHAVELA, sits on a wall smoking. He sees GRACIELA and approaches her, smiling.

POLICEMAN: Buenas. Doña Fernández…. Graciela…
 Those bags are too heavy. Let me help.

GRACIELA: **No. I'm fine.**

He takes one of the bags.

POLICEMAN: You look so tired. I apologise for the loud
 sirens day and night. We've been policing
 your area. Just trying to keep it safe for good
 campesinas like yourself.

The POLICEMAN walks with GRACIELA.

POLICEMAN: It's this way isn't it? I think Chavela takes
 this short cut with my daughter sometimes.

A beat.

POLICEMAN: She's growing up so fast, Chavela. She's grown into a very pretty girl. Mas linda, guapa.

GRACIELA stops. She looks at the POLICEMAN, on edge.

POLICEMAN: And what's in here that's so heavy?

He kneels and examines the contents of her shopping bag.

POLICEMAN: Ah, chili verde, tomates... frijoles... You must be making your famous pozole for Don Manolo.

A beat.

POLICEMAN: I saw him at the protest the other day. He looked a little confused, dazed.

Maybe you should keep him at home. It would be terrible if he forgets his address, and doesn't find his way back. I hear that happens sometimes.

They tussle over the food shopping. The POLICEMAN doesn't let go. He leans even closer.

POLICEMAN: That perfume smells nice.

The POLICEMAN finally lets go. GRACIELA hurries away.

POLICEMAN: *(After her)* Graciela!

She freezes.

POLICEMAN: You're wasting your time.

GRACIELA tries to walk a little faster.

POLICEMAN: Looking for what is not there. I'd hate to see you get hurt.

The POLICEMAN looks up at the sky.

POLICEMAN: Ah. The sun's come out.

A beat.

POLICEMAN: Give my regards to your family. We miss
 Manolo playing his music in the square.

The POLICEMAN exits whistling.

El Venado

A living room. A woman is listening to Reggaeton while browsing messages on her mobile phone. There's a knock at the door. Irritated she quickly hides the phone, sprays the room with fake incense, throws on some indigenous clothes and turns off the Reggaeton which she replaces with New Age music. Transformed into a SHAMAN, she opens the door.

MANOLO gingerly enters the abode clutching RAFAEL's red tracksuit top. The SHAMAN beckons MANOLO in.

SHAMAN: Señor. Come inside. Do not be shy.

MANOLO enters.

SHAMAN: Come. I see you that you carry the weight
 of the world on your shoulders. Is it your
 mother?

MANOLO shakes his head, no.

SHAMAN: An aunt then? *(impatient)* Mother-in-law?

MANOLO shows her RAFAEL's jacket.

SHAMAN: Son? Ah. Grandson?

MANOLO nods yes.

SHAMAN: I know of your pain. The Government is a
 viper's nest full of lying snakes.

 But I can help you. For a price.

130

The SHAMAN holds out her hand for money.

MANOLO gives her a few pesos but the SHAMAN wants more. Reluctantly, MANOLO roots around in his pockets; turning them out he finds some small change. The SHAMAN takes it all.

SHAMAN: Now sit. *(a beat)* Sit.

MANOLO watches apprehensively as the SHAMAN produces a clay pot and proceeds to fill it with the bones of small mammals, herbs and copal. She shakes a white powder on top of the concoction, circles MANOLO, then blows the white fumes into his face. Overcome by the potion MANOLO becomes disorientated.

The SHAMAN moves around MANOLO chanting loudly, pretending to call forth the ancients to help find RAFAEL.

Then, MANOLO begins to hear an ancient drumbeat. He freezes and enters a trance. The sham SHAMAN who can't hear the drums, waves her hand in front of MANOLO'S face. MANOLO doesn't respond. The SHAMAN becomes nervous, she thinks MANOLO is possessed. She backs out of the room.

Stag Dance and Drums

From the shadows and accompanied by the perscussion of ancient Náhuatl ritual, a STAG enters, cautiously.

It looks around to ensure it has not been followed there.

The STAG sees MANOLO and begins to approach him. But hunters have been tracking him. Before the animal can reach MANOLO, the hunters pounce.

MANOLO watches as the animal transform into RAFAEL... he watches as his grandson tries to evade his pursuers but is wounded over and over and over gain.

131

Amidst the violence, recorded verbatim voices of the Ayotzinapa students ring out.

MANOLO can hear the visceral distress and violence of the night they were attacked by armed men.

The chaos and gunshots become louder. MANOLO is torn apart by what he is hearing and witnessing. He is not sure if RAFAEL, or a stag, is writhing in pain before him.

Then the apparition vanishes as quickly as it arrived.

MANOLO is left stunned. He begins scraping at the floor where he thinks he saw RAFAEL fall.

SONG: <ins>NOT NOT NORMAL (SONG REPRISE)</ins>

> There's a sweet old man, digging in the mountains
> Searching for his daughter's son
> That's not normal
> But it's not not normal
>
> Yet another mass grave discovered in
> Guerrero
> Then another and another one
> That's not normal
> But it's not not normal
>
> And the bones of the people discovered in
> the hills
> Are the children of an endless war
> But no one knows if the bodies they uncover
> Are the bodies they are looking for
> They'll keep on digging for all their worth
> Deep in the bones of mother earth
> But oh that's not normal
> That should not be normal

MANOLO is now at Cocula dump, where the Ayotzinapa students were allegedly incinerated.

MANOLO'S AZTEC WARRIOR friend watches, as he begins to dig furiously, searching for evidence of his missing grandson Rafael.

But instead of finding his grandson's body, MANOLO discovers more and more mass graves.

CHAVELA arrives looking for her grandfather.

She tries to comfort him. Finally, CHAVELA pulls MANOLO to his feet. He reluctantly stumbles away from the gruesome scene, held tight by his grandchild. The AZTEC WARRIOR follows them home.

El Pozolero

Night. Police sirens can be heard in the distance. GRACIELA stands by the kitchen window. She looks cautiously through the shutters out on the street. The same POLICEMAN who stalked her earlier, loiters in the street with several of his henchmen.

ENSEMBLE: The policeman sits outside, propped on a low wall, watching Graciela's house, picking meat from his new gold teeth. Everyone calls him El Jefe now. It is whispered he has risen through the ranks, protects narcos and does their bidding which means he gets all the tequila and tamales he wants.

Nervous, GRACIELA leaves the window. She returns to her cooking and continues to chop up vegetables.

ENSEMBLE: And he's never without his trusted foot soldiers who seek out and spy on the Fernández home, forcing death threats under the door when Graciela has gone to the flower market or church, because she and Manolo refuse to be told that their child is dead. It's as if violence seems to lie in wait around every corner, along every dark alley and behind all

ENSEMBLE: For Graciela, this terror is when everyone out in the street is a new enemy and night becomes a killing ground for beasts of prey.

Clouds of smoke suddenly pour into GRACIELA's kitchen. Out of the haze emerges THE STEW MAKER.

He circles GRACIELA.

STEW MAKER: Sinaloa, Sinaloa. Yeah! Oye! Mi nombre es Santiago Meza Lopez... aka el Pozelero. To you I am the 'Stew Maker' *(laughing)* Google me!

SONG: MEXICAN MELTING POT

STEW MAKER: In the cartel kitchen,
I'm the cartel cook
When it comes to making stew
I wrote the book
It's a wave of flavour, it's pretty intense
So what are the key ingredients?
It's my mama's recipe slightly modified
I've added some potassium hydroxide
No cartel stew is ever complete
Without a little bit of meat

The STEW MAKER taunts GRACIELA, poking in her cooking pot and tasting her soup.

TANIA: Bring the body to the boil
And what have you got
Ooh ooh
It's a non metaphorical Mexican melting pot
It's true

STEW MAKER: If you want to criticise me,
 I welcome your critique
 But if you meet me,
 You might be too dead to speak
 Don't matter to me if you were stabbed or shot
 You'll all end up in my Mexican Melting Pot

TANIA: Mmm, so tasty

STEW MAKER: I could take this soup to bed

TANIA: Ooh

STEW MAKER: Go on carina give me some head.

The STEW MAKER pulls body parts out of the pot and finally RAFAEL's red jacket.

STEW MAKER: You can demonise me, you can call me a freak
 But it's worth it for 600 bucks a week
 I got a wife and kids and people to provide for
 I don't give a crap what this mother fucker died for
 Who's the loser in my beautiful brew?
 Who's dissolving in the cartel stew?
 It's the apple of your eye, it's you're pride and joy
 I'm boiling up your boy

TANIA: Bring the body to the boil
 And what have you got
 Ooh ooh
 It's a non metaphorical
 Mexican melting pot
 It's true

STEW MAKER: I'm making a pretty sweet soup
 For the narcos

ENSEMBLE: What's the flavour?

STEW MAKER: Ayotzinapos!
 Don't give a shit if you're innocent or not
 You'll all end up in my Mexican Melting Pot

TANIA:	Mmm, hey mama
STEW MAKER:	This soup is nearly done
TANIA:	Ooh
STEW MAKER:	Go on carina taste your son.

The STEW MAKER takes GRACIELA's cooking pot and evaporates. She falls to her knees.

DEATH arrives. He gently approaches GRACIELA and tries to comfort her. DEATH raises GRACIELA to her bewildered feet. He holds her in a deep embrace.

Traumatized by the STEW MAKER, she sinks into DEATH's arms.

He tries to lead GRACIELA away but she suddenly breaks free. GRACIELA straighten herself.

Rejected, DEATH slowly departs. Before disappearing, he turns back to look at GRACIELA, tips his hat and smiles.

Verbatim: Ayotzinapa

The ENSEMBLE quietly gathers in the space.

CHAPARRO, 20, FRESHMAN. …Around then…some parents were starting to arrive asking where their sons were. It was simply too sad to tell them that we didn't know… or that they had been killed. We couldn't do it…What we would say was: "Forgive us, ma'am, but we don't know your son,"…The truth was…we did…, but we didn't want to tell his parents that he couldn't be found

One woman…upon realizing that her son wasn't there… went outside to be alone, not to be around the parents who were finding their sons…She took out a lime and cut it. She is diabetic. She went to cut open a lime and drink its juice.

SONG: AYOTZINAPA (SONG OF THE TURTLES)

ANNE MARIE: The mother turtle bears her young
 Her eggs lie buried in the sand
 She has given them their birth
 She leaves her children in the earth
 She makes her way towards the sea
 She leaves her heart within the land
 Her little turtles in the sand

 Ayotzinapa

COYUCO BARRIENTOS, 21, FRESHMAN. The state police took us to the courthouse there in Iguala…asking if we wanted to go identify the police, the ones who had attacked us…. They took us into a room, behind a window…Right away, we were able to identify…the municipal police station chief. …we were able to identify nineteen.

 The little turtles in the ground
 Begin to break through to the air
 From the egg they struggle free
 And make their way towards the sea
 The little turtles learn to run
 The seabirds eat their prey alive
 Some little turtles still survive

GERMÁN, 19, FRESHMAN. We got the news that they had found another body, a compa that we called Chilango

ERNESTO GUERRERO, 23, FRESHMAN. …They found him… about three blocks from where it all happened.

RODRIGO MONTES, 32, JOURNALIST FROM IGUALA ….He had clear signs of torture. They had beaten him all around this part of his torso

ERNESTO GUERRERO, 23, FRESHMAN the autopsy showed that they'd skinned his face while he was still alive. They removed the skin of his face while he was still alive and he was still screaming when they took out his eyes.

The little turtles reach the sea
The little turtles start to grow
And in their hearts they start to learn
That to the land they must return
They grow a hardened leather shell
They turn their heads towards the shore
Not little turtles anymore

ENSEMBLE: Ayotzinapa
 Ayotzinapa

ANNE MARIE: The mother turtle bears her young
 Her eggs lie buried in the sand
 She has given them their birth
 She leaves her children in the earth

Aftermath

TLALTECUHTLI arrives. She walks slowly, exhausted, across the space.

ENSEMBLE: At full moon, bleeding and hideously
 scarred, Tlaltecuhtli, crawls and stumbles her
 way to ancient native ground at the edge of
 the sea, the land of Ayotzinapa. There she
 searches for the young creatures who have
 gone missing. There are many. Tlaltecuhtli
 tries to find them and keep them from harm
 but their spirits slip through her cold and
 tired fingers.

CHAVELA arrives. She watches MOTHER EARTH.

 Tlaltecuhtli curses the predators, the
 murderers, the conquistadors, the drug
 traffickers, the mass graves, the priests and
 politicians who do nothing to safe-guard the
 future of their young.

CHAVELA sinks to the ground.

ENSEMBLE: And Tlaltecuhtli overwhelmed by the weight
 of the missing and dying, cries

 'ENOUGH!'

MOTHER EARTH looks at the audience, then leaves.

Rise

CHAVELA lies on the ground, heartbroken, by all she's witnessed and heard.

The ENSEMBLE approaches.

Spoken Word: Chavela Arriba!

ENSEMBLE: She sits with her head clasped tight in her
 hands
 A wounded coyote she shivers and cries
 'Is there no way to stop gunmen and their
 killing franchise?
 On the TV news politicians shout 'Seguro que si!'
 Let us carpet bomb Guerrero with missiles of
 ecstasy
 It will curb the demon hunger and make even
 cruel men fall in love… or choke each other
 senseless in this scrap yard of the dead.
 And everyone laughs *(pause)*
 Except Chavela. Mexico querido, herido. This
 is her country and this is no joke.

 What is a child supposed to do when its the
 end of her world?

When life is not worth living and all hope is
dead.
When there's nothing left to separate the beast
from the man who is out of his head,
In this drug filled arena
Chavela hears her brother whisper

ENSEMBLE: Arriba, Chavela, Arriba
 Arriba, Chavela, Arriba

The day her world went belly up she had a
front row seat.
Her angel got abducted which made her
mother weep.
The shadows grew long and it wasn't even night
The missing warrior was her sun, moon, and
wings that helped her to soar as high as a kite
But to 'arriba' is to stand tall, head held high
So say the ancients looking down from the sky
They cry 'you're mighty as the mountains,
remember to oblige
The Mixtec blood in your veins is a means to
survive
with your brave Toltec torso
your Mayan strong thighs
Obsidian Aztec gleaming eyes
And Olmec jewelled feet which can outrun the
traffickers she yearns to pulverize.'

CHAVELA sits up.

What are we supposed to do when our world
is at war?
When life no longer matters especially if you're
poor,
All we ask for is peace to separate the man
from the beast
Burning alive in his drug filled arena
Chavela hears her brother call out... ARRIBA

ENSEMBLE: Arriba, Chavela, Arriba
 Arriba, Chavela, Arriba

 Do you fear her sun-burnt cinnamon skin?
 She is semi indigenous and every right to be.
 Does her defiance upset you? Are you ready
 to flee?
 From her so called criminal tendencies and
 narcotic disease?
 Or is she but a stone in your leather-soled
 shoe?
 Like the 43 Normalistas the government bites
 and chews
 No one can destroy such spark
 Indestructible, unbreakable, perpetual, to the last
 Until our children and our children's children
 fly free… Mariposas Mexicanas… into a brave
 new world.
 We reach out, across all borders seen and unseen
 Rise! The earthquake wakes us,
 Because we are what our mothers taught us
 and survival is thirst.
 Sleeping Mexico, Mexico Lindo, we refuse to
 be cursed.

CHAVELA is now standing. She goes to the ofrenda and retrieves RAFAEL's tracksuit top. She puts it on and hugs herself.

ENSEMBLE: Arriba, Chavela, Arriba
 Arriba, Chavela, Arriba
 Arriba, Chavela, Arriba
 Arriba, Chavela, Arriba

Finally, CHAVELA removes her mask, revealing the actor beneath. The actor takes one of CHAVELA's windmills and plants it in the ground at the centre of the stage.

SONG: HISTORY OF MEXICO (REPRISE)

ALVARO: What we know is not the only way it was
The truth is not necessarily what they say it was
But the 43 have disappeared,at least that much we know
And two more people have disappeared since the start of the show

Combine some power with some men,
And history comes round again
It's not an 'if' it's more a 'when'
But there's so much more to go...

Verbatim: Justice For All

JORGE HERNÁNDEZ ESPINOSA, 20, FRESHMAN. I want to graduate from the college and become a teacher. I want to tell my children and grandchildren…that I studied in the Raúl Isidro Burgos Teachers College at Ayotzinapa. When I do, I will feel proud about saying that I was there during the massacre of September 26, when the whole country, the whole world heard the news and supported us. Some people criticized us, but everyone heard the news from Ayotzinapa about how we were attacked. I am proud to say that I am part of the freshman class; I am an Ayotzinapa Teachers College student.

COYUCO BARRIENTOS, 21, FRESHMAN. There is a phrase that many people here say: Whoever sees an act of injustice and does not combat it, commits it.

Recordings of student testimonies follow in Spanish.

The Mexican Sun

The ENSEMBLE gather CHAVELA'S windmills and starts to plant them in the earth. They invite audience members to help them.

SONG: EL SOL DEL CIELO

ENSEMBLE:
Por tí robaré el cielo del sol
La luna esconderé
Por ti hundiré la tierra en el mar
Por tí robaré el sol

El sol del cielo
El sol del cielo
El sol del cielo
El sol del cielo

Por ti las montañas desgarrare
La tierra sacudiré
La lluvia de fuego hare caer
Por ti robaré el sol

El sol del cielo
El sol del cielo
El sol del cielo
El sol del cielo

Wind gently blows, bringing the 43 windmills to life.

El sol del cielo
El sol del cielo
El sol del cielo
El sol del cielo

<u>Curtain Call : Dia De Los Vivos</u>

<u>SONG: DIA DE LOS VIVOS</u>

ALVARO: For the sons of Ayotzinapa
We are turning every stone

ALVARO & TANIA: For the sons of Ayotzinapa
They are burning every bone

ENSEMBLE: Dia de los vivos
De los vivos we will sing
We will meet them on the day of the living
I hear their voices in the mountains
Through the mountains let them ring
On the Dia De Los Vivos
To the living we will sing

All our sons of Ayotzinapa
Are not forsaken, they survive
All our sons, alive when taken
Shall be returned to us alive

A los vivos, a los vivos
To the living we will sing
a los vivos
A los vivos, a los vivos
Oh vivos se los llevaron, vivos los queremos

Dia de los Vivos
De los vivos we will sing
We will meet you on the day of the living
I hear your voices in the mountains
Through the mountains let them ring

On the Dia De Los Vivos
To the living we will sing
On the Dia De Los Vivos
To the living we will sing

The search for justice continues.